JOHN CONSTABLE
THE MAN AND HIS WORK

CARLOS PEACOCK

JOHN CONSTABLE
the Man and his Work

The trees and the clouds seem to ask me to
try and do something like them.

JOHN CONSTABLE

NEW YORK GRAPHIC SOCIETY LTD
Greenwich, Connecticut, U.S.A.

First published in Great Britain 1965 by
JOHN BAKER (PUBLISHERS) LTD

First published in the U.S.A. by
NEW YORK GRAPHIC SOCIETY LTD
Greenwich, Connecticut 06830

SBN 8212-0408-4
Library of Congress Catalog Card Number
79-164882

Reprinted April 1965, November 1965, 1966,
revised edition 1971

Printed in Great Britain by
W & J Mackay Ltd, Chatham, Kent

TO BENJAMIN BRITTEN
ALSO AN EAST ANGLIAN

CONTENTS

ILLUSTRATIONS

IN THE TEXT

THE PLATES

COLOUR

7 View of a wide landscape with trees in foreground. Pencil and water-colour
Victoria and Albert Museum

8 Waterloo Bridge from Whitehall Stairs. Oil
Victoria and Albert Museum

9 Portrait of John Charles Constable, the artist's eldest son. Oil
Private Collection

10 Hampstead Heath with passing shower. Oil
Private Collection

11 Study for 'The Glebe Farm'. Oil
S. Hahn Esq.

12 View on the Stour with Flatford Old Bridge. Oil
Hamilton Trust

13 Sky study with tree. Water-colour
British Museum

14 Study of poppies. Oil
Victoria and Albert Museum

15 Hampstead Heath from near Well Walk. Water-colour
Victoria and Albert Museum

MONOCHROME

16 Moonlight landscape. Oil
S. Hahn Esq.

17 A harvest field. Oil. *Circa* 1796–7
Mrs A. L. Gracie

18 Etching by John Constable from his painting 'A Harvest Field'
Mrs A. L. Gracie

19 Tottenham Church. Oil
Metropolitan Museum of Art, New York

20 Boy at an easel—the artist's son, John Charles Constable
Hurlock Family Collection

21 Malvern Hall. Oil
The National Gallery

22 View at Highgate. Oil
Mr and Mrs Paul Mellon

23 Lock at Flatford. Oil
Brigadier A. L. Matthews

24 Boy by a milestone. Oil
Private Collection

25 Head of a girl—perhaps the artist's sister Mary Constable. Oil
Private Collection

26 Sketch relating to 'The Valley Farm'. Oil
Miss C. M. Williams

27 Flatford Mill. Oil
Victoria and Albert Museum

28 Portrait of Mrs Maria Constable. Oil
Tate Gallery

29 Sketch for 'The White Horse'. Oil
National Gallery of Art, Washington

30 Summer landscape near Dedham. Oil
Mr and Mrs Paul Mellon

31 Evening landscape after rain. Oil
Mr and Mrs Paul Mellon

32 Study of ash tree. Pencil
Victoria and Albert Museum

33 Stoke-by-Nayland. Oil
Metropolitan Museum of Art, New York

34 Study of clouds. Oil
Tate Gallery

35 Landscape with horses. Oil
Mrs J. Woodman

36 Study for 'The Hay Wain'. Oil
Victoria and Albert Museum

37 Salisbury Cathedral. Pencil
Victoria and Albert Museum

38 Sketch for 'The Lock'. Oil
National Gallery of Victoria, Melbourne

39 Pond at Hampstead. Water-colour
British Museum

40 Salisbury Cathedral from the Bishop's Garden. Oil
Metropolitan Museum of Art, New York

41 Study for 'The Leaping Horse'. Oil
Victoria and Albert Museum

42 Hampstead Heath. Oil
Harold A. E. Day Esq.

43 Landscape with cottage and rainbow. Oil
The Royal Academy

44 Parham Mill, Gillingham. Oil
Mr and Mrs Paul Mellon

45 Helmingham Dell. Oil
Tate Gallery

46 View of London with Sir Richard Steele's house. Oil
Mr and Mrs Paul Mellon

47 Hadleigh Castle. Oil
Tate Gallery

48 Crossing the Ford. Oil
The Guildhall Art Gallery

49 London from Hampstead Heath. Water-colour
British Museum

50 Landscape with double rainbow. Water-colour
British Museum

CONSTABLE AND THE SEA
COLOUR

51 Weymouth Bay. Oil
National Gallery

52 Brighton Beach with colliers. Oil
Victoria and Albert Museum

53 Brighton Beach. Oil
Victoria and Albert Museum

54 Coast scene with breaking cloud. Oil
The Royal Academy

MONOCHROME

55 Shipping in the Thames. Pencil and grey wash
Victoria and Albert Museum
56 Harwich Lighthouse. Oil
The National Gallery
57 Weymouth Bay. Oil
Victoria and Albert Museum
58 Shipping on the Orwell. Oil
Victoria and Albert Museum
59 Sky study over a rough sea. Oil
Benjamin Britten Esq., C.H., O.M.
60 Sea and shipping. Water-colour
Alan Pilkington Esq.
61 Study of sea and sky—probably at Brighton. Oil
Tate Gallery
62 Hove Beach with fishing boats. Oil
Victoria and Albert Museum
63 Brighton Beach. Oil
Victoria and Albert Museum
64 Brighton Beach. Oil
Victoria and Albert Museum
65 Hove Beach. Oil
Victoria and Albert Museum
66 Coast scene—stormy weather. Oil
The Royal Academy
67 The Marine Parade and Chain Pier, Brighton. Oil
Victoria and Albert Museum
68 Coast at Brighton—stormy day. Oil
Mr and Mrs Paul Mellon
69 Coast scene, evening. Perhaps at Brighton. Oil
Victoria and Albert Museum
70 Portrait of Charles Golding Constable, son of the artist. Oil
Benjamin Britten Esq., C.H., O.M.
71 Folkestone Harbour. Water-colour
Victoria and Albert Museum
72 Folkestone Harbour from the sea. Water-colour
British Museum
73 Seaport with passing shower. Water-colour
British Museum
74 Littlehampton, Sussex. Water-colour
British Museum

ACKNOWLEDGEMENTS

The extracts from Van Gogh's letters are quoted by kind permission of Messrs. Thames & Hudson; and the passages from 'An Essay on Landscape Painting' by Kuo Hsi, by courtesy of John Murray.

In preparing this book I have made use of all the well-known sources of material, but I am particularly indebted (as all lovers of Constable must be) to the work of Mr R. B. Beckett whose untiring researches have thrown so much new light on Constable's life and art.

I wish to express my thanks to the private collectors and Trustees of Public Galleries who have kindly allowed me to reproduce paintings and drawings in their possession.

The Man and His Work

CONSTABLE was born at East Bergholt on the Suffolk side of the river Stour on 11 June 1776. The house where he was born has now disappeared, but its prosperous Georgian solidity exists for us still in a number of Constable's paintings and in the pages of his sketch-books. Constable's father (like Rembrandt's) was a miller and the owner of water-mills at Flatford and Dedham, and two windmills at East Bergholt. In a community largely dependent on the growing of corn, the mill was in a sense the focal point of its existence, and the successful miller was consequently a man of position and influence. Thus Golding Constable, the artist's father, had a range of social and business contacts which extended well beyond the ordinary parochial bounds. To young Constable this was not only an advantage socially; it also provided opportunities for getting to know the East Anglian countryside—those scenes, as he afterwards confessed, that made him a painter.

What made Constable different from the majority of his contemporaries was his attitude towards the things he saw. He was never, as so many other landscape artists were, a conscious seeker of the picturesque; nor did he paint, as Gainsborough so often did, such things as cottages and peasants with a quality of stylized elegance calculated to produce a romantic effect. The robust quality of his painting was largely due to an intimate knowledge of the subjects he chose. As an artist he was virtually self-taught and his periods of formal study amounted to little more than a process of directive discipline. His real master was his own sensitive and perceptive eye, and it was through a study of nature rather than by a study of academic principles that his artistic philosophy was evolved.

Constable went to school at Lavenham and afterwards in Dedham. It was not education in the grand sense, but one has only to read his letters to realize the inadequacy of much that passes for education at the present day. From his schooling and his home background he acquired an understanding of life and a poise of mind that put him at ease with all classes of humanity. He had his prejudices and limitations of course, but they are always expressed with a downright honesty that makes them almost endearing. From his schooldays he had tried his hand at painting, and his preoccupation with his artistic visions sometimes made him an inattentive pupil. He was fortunate in finding at East Bergholt a plumber named Dunthorne who shared his taste for art, particularly landscape painting. Constable's father, however, had no wish for his son to become a professional painter. He had first intended John for the Church, but when the young man showed no inclination for the studies, he decided that his son should go into the milling business. For a year young John worked in his father's mills and so acquired a

first-hand knowledge of the miller's trade.[1] What he learned then probably stood him in better stead than all the formal instruction in art he ever received. From his practical experience of milling he developed a keener eye for skies and weather and a deeper understanding of his native landscape. From childhood he had known the drama of the mill: the water churning under the great wheel, or spilling away through the sluices; he'd seen the white mill sails turning under the wide East Anglian skies, and the barges on the Stour drawn by splendid Suffolk horses with crimson fringes decorating their collars.[2] These familiar things entered now into some deeper level of his consciousness and, like rich veins of ore, were to become in later years an unfailing source of subjects for his brush. But before the vision could be translated into art the mechanics of painting had to be mastered and the problems of form and tonality resolved. Lacking the natural facility which such men as Bonington and Turner so patently possessed, young Constable found the path of professional art a long and often discouraging one.

Though not over-sanguine about John's prospects as an artist, Mrs Constable was more favourably disposed to the idea than her husband Golding. Perhaps it pleased her mother's vanity to think of her son in such a genteel profession; or perhaps with feminine intuition she saw more clearly into the future. At any rate she decided it would be to his advantage if he met Sir George Beaumont, a collector of pictures, an amateur painter himself, and a patron of the arts. Sir George Beaumont's mother lived at Dedham, so the introduction was easily arranged. Through this introduction Constable got his first sight of a painting by Claude, the 'Hagar' now in the National Gallery. Sir George also possessed a number of water-colours by Girtin and Cozens which he showed Constable as well. Both Claude and Girtin were to influence Constable profoundly, but of the two Girtin was to prove technically the more useful. To us in the twentieth century Girtin may seem as much an old master as Claude, but in Constable's day Girtin was a 'modern', an innovator and one of the first to paint landscape in naturalistic tones. The fact that Girtin was almost exclusively a water-colourist tends to make us less aware of his originality. He was, in fact, in his later work almost a 'pointilliste', using small blots of wash to build up his forms. When seen at a distance the gaps between the blots disappear and the drawing gains in power and luminosity.

Constable was eighteen when he saw these works, a country youth with a strong desire to paint but with no footing yet in the world of art. In 1795 his father agreed that he should go to London to find out what his chances might be. In London he made the acquaintance of John Thomas Smith, a draughtsman and engraver, known as 'Antiquity Smith'. From him Constable got encouragement and some practical advice,

[1] Had Constable failed as an artist, he might have been as successful in the milling business as his father was. The hand that painted windmills and rainbows possessed, it seems, the broad sensitive thumb which enables a miller to judge a sample of flour by sifting it between his thumb and forefinger. The Victorian writer Juliana Horatia Ewing says in a prefatory note to her tale *Jan of the Windmill*, 'that this story was more or less suggested to me by hearing that Constable, the great Wiltshire (*sic*) landscape painter, was wont to boast of his miller's thumb....'

[2] David Lucas, Constable's engraver, contradicts Leslie's statement that the Stour barge horses had a crimson fringe on the collar. In the picture 'The Leaping Horse' Constable has painted this fringe; but Lucas in his annotated copy of Leslie's Life says that Constable merely introduced the fringe as a device for bringing a note of red into the picture. Personally, I find it difficult to believe that Constable, who was always such an accurate observer of Suffolk things, should in this case have drawn on his imagination.

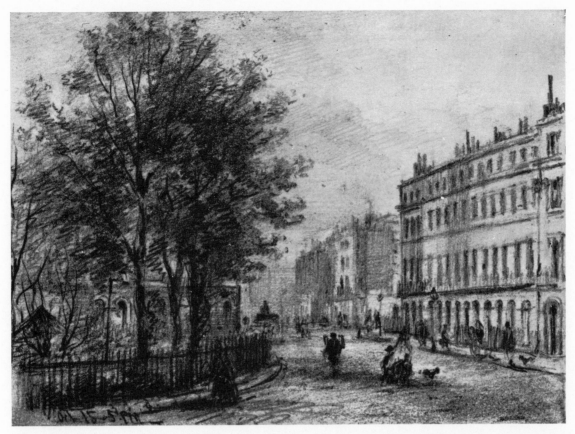

(i) *Fitzroy Square, London. Pencil. Inscribed by the artist: 'Oct. 15. 5 p.m.'*

but no great inspiration. Smith's own drawings were in the topographical manner of the eighteenth century, pleasant and charming in their way, but without originality. Indeed Smith's chief value to Constable was that he provided some focus for his artistic bent.

Smith was at this time publishing a series of etchings of picturesque cottages, and Constable assisted him by making sketches that might be used as subjects for this work. Constable, referring to them in a letter to Smith, says: 'You flatter me highly respecting my "cottages", and I am glad you have found one or two amongst them worthy of your needle.' Constable now spent his time between East Bergholt and London, though without producing anything spectacular in the way of art. Golding Constable must have grown impatient at the lack of results and was probably inclined at this stage to dismiss his son's taste for painting as nothing more than a young man's whim. His impatience was justified too on practical grounds, for he needed extra help now in running the family business. In 1797 Constable was recalled to Bergholt to work in his father's counting-house.

To the young artist this summons home seemed the final blow to all his hopes. Rather in the tone of young Werther he laments to Smith: 'I see plainly that it will be my lot

17

to walk through life in a path contrary to that in which my inclination would lead me.' But fate was kinder to him than he expected. In 1800 he was admitted as a student at the Royal Academy Schools.

What influence contributed to his return to London we do not know. Many years later he was to confess to John Fisher: 'For long I foundered in the path—and tottered on the threshold—and there never was any young man nearer being lost than myself.'

Perhaps the time spent in his father's counting-house helped him to make up his mind and gave him a clearer sense of his true vocation. At all events he had continued to paint while working for his father and his art was beginning now to show signs of promise. Possibly Golding himself had begun to see that his son would make a better artist than miller.

In 1798 Constable had got to know Joseph Farington, a pupil of the landscape painter Richard Wilson and a man closely connected with the artistic life of the time. Farington's knowledge of Wilson's technique probably helped him to appreciate the genuine qualities of Constable, and he acted as the young man's friend and adviser during his early years in London. With Farington's help Constable was able to raise the standards of his art to a professional level, though it entailed the tedious discipline of drawing from the antique and making copies from the old masters. More important from Constable's point of view was the fact that Farington possessed a first-hand knowledge of Wilson's methods. By a study of Wilson Constable learned to combine solidity of paint with luminosity of tone. At Farington's suggestion he copied paintings by Ruysdael and Wynants, and in gaining an understanding of the Dutch masters came to appreciate more fully the early landscapes of Gainsborough which he had always admired. Gainsborough, like Constable, was a Suffolk man and had painted the places that Constable knew intimately. (It is worth remembering that Gainsborough's 'Cornard Wood', now in the National Gallery, once belonged to Constable's uncle.) In 1799 Constable writes from Ipswich: 'It is a most delightful country for a painter. I fancy I see Gainsborough in every hedge and hollow tree.'

The presence of Gainsborough haunts Constable's early work—Gainsborough and the Dutchman, who in turn had influenced him, Ruysdael. Painting in the Ruysdael-Gainsborough manner, with occasional recourse to Wilson and Claude, Constable began his career as a professional landscape painter. In 1802 he exhibited for the first time at the Academy. He had made his start, but it brought him neither fame nor recognition. It was hardly surprising. To paint the quiet, unspectacular Suffolk landscape with sensitive precision was not enough to set the public talking. That kind of art had caused no stir in Wilson's day and it did not do so now. What the public looked for was not insight into nature, but nature rendered in terms of the obviously dramatic or the conventionally picturesque. Constable's friends and relatives, taking the practical and worldly point of view, probably felt that his subjects were too 'ordinary', and that if he were to paint a more dramatic kind of scenery he might succeed at last in catching the public eye. This may have been their well-meaning motive in persuading him to make a tour of Derbyshire in 1801 and of the Lake District in the autumn of 1806. In these tours he went farther afield than he ever went again.

From the Derbyshire tour he brought back a number of water-colour drawings, sensi-

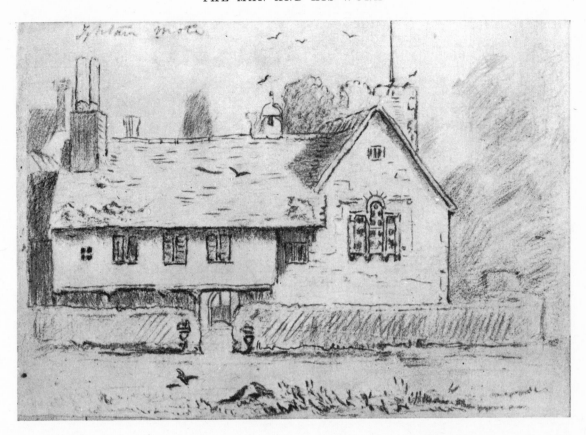

(ii) *Page from a sketch-book used by Constable in Suffolk in 1816 and later on his honeymoon in Dorset*

tive in line but unambitious in colour and showing little technical advance over the ordinary topographical drawings of the eighteenth century. The tour of the Lakes was a great deal more rewarding. Though Constable found the mountain scenery oppressive, he responded to it with a remarkable depth of feeling. Here his knowledge of Girtin influenced his style. It was the kind of landscape that Girtin painted supremely well— bare stretches of hill and mountain that could be brushed in with broad sweeps of wash; and the deep browns and greens of the autumnal landscape recalled the tones of Girtin's palette. If Constable lacked Girtin's purity of colour, he made up for it by his sensitivity to atmosphere and his ability to record the form and motion of a sky.

It is perhaps appropriate here to say something specific on the subject of Constable as a water-colourist because it seems to me that in this medium he has been consistently underrated. Perhaps this is due to the more spectacular achievement of Turner. For him water-colour was a particularly congenial medium and indeed no other artist has used it with such consummate mastery. In it all Turner's poetic sensibility and his magnificent colour sense are expressed in a range and variety of art which is the quintessence of his genius. For Constable, on the other hand, water-colour was chiefly used as a kind of

shorthand technique by which the effects of nature could be noted more swiftly and accurately than was sometimes possible in the more opaque medium of oils. Light, he found, could be captured well enough on a sheet of white paper, and the translucent tones of water-colour laid in with broad and broken washes could admirably reproduce the varied patterning of sky and cloud, as well as the forms of trees and the play of sunlight over dewy grass.

If one wants to understand the essential difference between the art of Constable and that of Turner, a comparison between their water-colours will perhaps show it best. Yet in noting the difference one is reminded too of the things they had in common, the debt, for instance, they both owed to the pioneer work of Girtin and Cozens. Both, too, were acute observers of nature and both shared the Romantic's passion for light. Where they differed was not in fundamental principles, but in their way of looking at things. With Constable it is the sensation of the moment that counts supremely, and one feels, especially in the later water-colours, that he deliberately puts imagination aside in order that the subject he is painting may be freshly seen and the mind cleared of falsifying preconceptions. For him light is the means by which reality may be heightened, by which a tree or cloud may take on some particular significance in the ordinary scale of things. What he seeks to do is not to 'improve' nature, not to rub off the bloom in the name of higher art, but to paint exactly what he sees in the clearest, freshest tones; so that even today the blues and greens on the pages of his later sketch-books flash out like pure colour rays reflected in a prism.

In Turner's art the vision tends to be more inward, more consciously distilled, so to speak, and even when he paints most closely to nature, one feels that the imagination has at some point intervened and added an element of studied art. For him light is not so much a means of heightening reality as of diminishing it, of dissolving away the solid form and rendering it more mysterious and remote. And as he grew older he became—unlike Constable—a painter of a private world, a world of mists and nuances, like some vision of the earth itself before the primal vapours coalesced. Here nature is so transformed and rarefied that the forms of things are often no more than vague opacities in tides of tinted light. (Constable says of the paintings Turner exhibited at the Royal Academy in 1828: 'Turner has some golden visions—glorious and beautiful, but they are only visions—yet still they are art—and one could live and die with *such* pictures in the house.') Even in his later topographical drawings Turner gives his subjects the filmy quality of dreams, using sun-shaft and rainbow to dissolve away reality and transform a view of town or river into a vision of engulfing light. With Constable water-colour was always a factual, on-the-spot medium, and in his latter years, when he tended to compose his oils in the studio and to repeat old subjects rather than embark on new, it was in water-colour that his most original work was done. His visits to Sussex are recorded in a series of drawings of wonderful breadth and freedom, as fresh now as on the day they were painted.

Two of his water-colour drawings, 'Old Sarum' and 'Stonehenge', now in the Victoria & Albert Museum, are of a different order and show Constable producing in water-colour the kind of Academy art which he so often produced in oils in an attempt to win public favour by sacrificing spontaneity and freshness for the more saleable quality of 'finish'.

20

Both drawings are worked up from sketches and both show in their elaboration of technique and in their dramatic effects the unmistakable influence of Turner. Here sky and rain-cloud swirl over the mound of the extinct city and the desolate Druid stones, in a flux of stormy light which seems, like an eroding tide, to dissolve away these memorials of man and merge them once again in the processes of nature. In the case of Turner's art, the dissolution of material form by light is, perhaps, a symbolic expression of his own philosophy, that inherent pessimism which saw the physical world as something impermanent and accidental, where matter itself would ultimately disappear and only light would exist as the pure and final absolute. Though Constable does not go as far as this, he expresses in these drawings, as he does more forcibly in his oil sketch of Hadleigh Castle, his sense of the mutability of things and the shifts and changes of evolving time.

Yet for all their impressiveness, these large drawings are not the essential Constable, but rather a reminder that neglect and criticism had produced a kind of dichotomy in his art, a double standard in which the walls of the Academy represented the public eye and a level of art necessarily more conventional and technically finished than his own standard of absolute freshness and spontaneity which shocked all but the initiated few. Or to put it another way, there was Constable the Royal Academician who for the sake of his family finances and his public reputation adopted sometimes a tamer and more conventional style of art in the hope of placating the critics and of winning over a hesitant buyer. Luckily there existed also that other side of him, the pioneer and dedicated artist, contemptuous of the Academy ('There has been sad work lately in the Academy—but it is too contemptible to talk about, as is usual in bodies corporate—the lowest bred and the greatest fools, are the leaders.'), that other Constable who never compromised his principles and who had learnt from bitter experience not to care too much what the critics and the public had to say.

In his last years, when the academic side of him seems sometimes to have got the upper hand, it is reassuring to turn to the later sketch-books—those intimate journals of his vision—and to find that in water-colour at any rate he never ceased to break new ground. In these wonderfully modern-looking drawings, with their running washes of acid blues and greens, he carries the art of water-colour to a new level of perfection. Indeed if one takes the whole body of his work in water-colour, beginning, say, with the sketches done in the Lake District in 1806 and culminating with such things as the 'Landscape with a Double Rainbow', now in the British Museum, it is difficult to resist the conclusion that if he had done nothing else he would still have been one of the greatest artists of the nineteenth century.

While in the Lakes, or shortly afterwards, he also made some sketches of Lakeland subjects in oils which have the same broad qualities as his water-colours. Some of these oils are executed in the thin, fluid manner of the later Gainsborough (Constable remembered that Gainsborough had made a sketching tour of the Lakes in 1783) and others, probably those painted in the studio when Constable returned, are loaded with touches of impasto which foreshadow his later style. On the whole this tour of a mountainous country that Constable found uncongenial seems to have acted as an unexpected stimulus by presenting him with a new set of artistic problems to solve. One problem,

21

however, remained stubbornly insoluble: how to make the public buy his work. The paintings based on this expedition to the Lakes and exhibited at the Academy and the British Institution in 1807 and 1808 were all unsold.

In the spring of 1802 Constable had taken a calculated risk. He had turned down the offer of a post as drawing master at the military school at Windsor. Had he taken the job he would have been financially secure, but it would almost certainly have ruined his chances of becoming an original painter. Having rejected one source of income, he was forced to try his hand at something else. Like many other hard-pressed artists, including Van Gogh in his desperate Antwerp days, he clutched at the straw of portrait painting. Here he was luckier than Van Gogh, for he was able with the help of friends to obtain a number of commissions as well as a few copying jobs. As an indirect result of one of these commissions he painted his first real masterpiece in landscape.

Through his friendship with the Dysart family he was asked to paint a portrait of Lady Dysart's nephew, Henry Greswolde Lewis, who owned Malvern Hall in Warwickshire. Constable visited the house and during his stay there painted a view of the Hall as seen from across a stretch of ornamental water in the park. This lovely picture of Malvern Hall, now in the National Gallery, represents one of the landmarks of English romantic art. If one agrees with the generally accepted date of it—1809—it may be said to sum up and justify that decade of Constable's art which began in 1799, a decade of struggle and experiment in which too often, under pressure of other people's criticism, he allowed his individuality to be effaced by making his performance look (as he confesses to Dunthorne) like the work of other men. In his painting of Malvern Hall he is completely and triumphantly himself.

Of all the influences in Constable's life, that of John Fisher was probably the most decisive, both in the matter of his art and in the pattern of his human relationships. But for Fisher his marriage might have been longer delayed and on material grounds it might have been a good deal less happy. In the crises of his life it was to Fisher that Constable turned, and by his encouragement and his real appreciation of Constable's art Fisher supplied the kind of stimulus that the artist most needed. Thus as an individual, and as far as any single whole-hearted supporter could, Fisher acted as a substitute for that enlightened and discerning public which Constable always hoped for but never won.

It is almost certain that Constable and Fisher met for the first time at Salisbury in 1811, a month or two after young Fisher had come there to be ordained. Constable was then staying with John Fisher's uncle, Dr Fisher, Bishop of Salisbury. The friendship between Constable and the Fisher family was an old one that had begun and ripened on East Anglian soil. Dr Fisher had been in earlier days Rector of Langham in Essex, but being also a Canon of Windsor he delegated his Langham duties to a curate. He was, however, frequently in the neighbourhood and was a regular visitor to Dedham. He had always taken a kindly and practical interest in Constable and his art, an interest which was to extend over a quarter of a century, as Constable himself gratefully acknowledged when he reminded the Bishop in 1824 that he had been 'his kind monitor for twenty-five years'. The word 'monitor' tends to suggest the kindly but rather didactic attitude the Bishop adopted towards the younger man whose tendency to put dark clouds in his pictures was something of which he did not approve.

Constable's relations with the Bishop's nephew, young John Fisher, were on a very different footing. The two men seem to have taken to one another from the start, and on that first meeting in the autumn of 1811 Constable may have taken Fisher into his confidence and asked his advice on the course he should adopt regarding the attachment that had grown up between himself and Maria Bicknell, granddaughter of Dr Rhudde, Rector of East Bergholt. This seems all the more likely because soon after his visit to Salisbury Constable let it be known that he and Maria were virtually engaged. Constable had known Maria since her childhood days, so the step might have seemed natural enough; but in disclosing their attachment the couple brought down a storm of disapproval on their heads. The trouble was that old Dr Rhudde was a rich man whose fortune Maria was expected to inherit, and having a high opinion of his own social importance he believed that a granddaughter of his should marry someone of greater consequence than the local miller's son whose artistic aspirations made no amends for his deplorably small income. Maria's parents took fright at the Rector's anger, with its looming threat of disinheritance, and forbade any further meetings between Constable and Maria. The two, however—without the Rector's knowledge, it seems—continued to correspond.

At this time Constable's only chance of making money was still through portrait painting. While at Salisbury he received a commission to paint a portrait of the Bishop, a tangible proof that the 'kind monitor' knew how to do the young man a tactful service. More to Constable's liking, however, were the opportunities he had of painting Salisbury and the country round it. At the Academy in 1812 he exhibited his first painting of

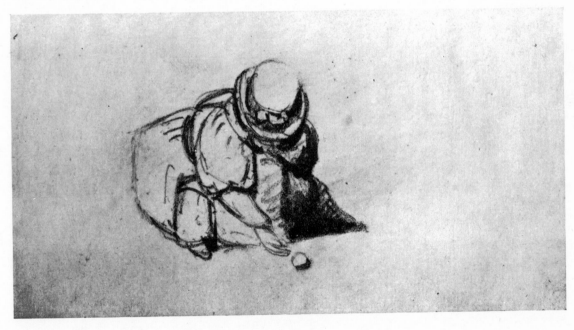

(iii) *A child playing with a marble*

23

Salisbury, a prelude to that wonderful series of paintings and sketches which were afterwards to stand among the greatest achievements of his art. Thus through the friendship of the Fisher family, Salisbury and its neighbourhood came to occupy the same place in his affections as the Valley of the Stour.

Some success came Constable's way in 1814 when, after so many fruitless showings at the Academy and the British Institution, he sold a landscape painting for the first time. By the sale of this picture he considered that he had at last attained the status of a professional painter. This initial success was followed shortly afterwards by the sale of another landscape, 'A Lock on the Stour', purchased by a stranger who, Constable explains in a letter to his uncle, 'bought it because he liked it'. The sale of these pictures gave Constable much needed encouragement at a crucial stage of his career. Years later he told John Allnutt, his first landscape purchaser, that he had 'been the means of making a painter of him by buying the first picture he had ever sold to a stranger; which gave him so much encouragement that he determined to pursue a profession in which his friends had great doubts of his success'.

Inspired by new hopes Constable spent the summer and autumn working in Suffolk, painting even more directly from nature than he had hitherto done. His picture, 'Boat-Building near Flatford Mill', now in the Victoria & Albert Museum, was painted entirely in the open air. It was probably at this time that he began his practice of making an on-the-spot sketch as a kind of visual memorandum for future versions on a larger scale. A letter written to John Dunthorne senior shows that the idea had long been in his mind: 'I am determined to finish a small picture on the spot, for every large one I paint. This I have always talked about, but have never yet done.'

These months of careful study in the fields brought a new vitality and richness to his art. 'I believe', Constable reports to Maria, 'I have made some landscapes that are better than usual'. But in painting 'the endeared scenes of Suffolk', as he calls them, he was continually reminded of Maria's absence. Writing to her from East Bergholt he hints at the bitter pang of old associations: 'I believe we can do nothing worse than indulge in useless sensibility, but I can hardly tell you what I feel at the sight, from the window at which I am writing, of the fields in which we have so often walked. A calm autumnal setting sun is glowing on the gardens of the rectory and on those fields where some of the happiest hours of my life have been passed.'

Debarred from meeting under the Bicknell roof, the lovers had to content themselves with an exchange of letters or a snatched meeting in St James's Park. The outlook seemed bleak indeed. As Constable wrote to Maria in the autumn of 1814, 'Fate is still savage'.

The following year was for Constable one of loss and gain. The death of his mother, his wise sympathizer and counsellor, was a sad blow to him. She had always believed in him as an artist, and though she held the view that his best chance of success was in portrait painting she had always given him all the help and encouragement in her power. A few days after Mrs Constable's death Maria also lost her mother. 'It is singular', Constable wrote, 'that we should, both of us, have lost our nearest friends, the nearest we can have in this world, within so short a time; and now, more than ever, do I feel the want of your society.'

24

The illness and death of Mrs Bicknell seem to have made Maria's father less cautious in allowing meetings between Constable and Maria. Perhaps after his wife's death he found his crotchety father-in-law, Dr Rhudde, a less overshadowing presence. He had already given Constable permission to see Maria in the Bicknell home 'as an occasional visitor', and Maria had communicated the news to Constable with the comment: 'From being perfectly wretched, I am now comparatively happy'.

News of these meetings, however, eventually came to Dr Rhudde's ears. His reaction was immediate and violent. After nearly a year of permitted meetings and the comparative happiness they afforded, Maria had to report to Constable on 7 February 1816: 'The doctor has just sent such a letter that I tremble with having heard only a part of it read. Poor dear papa, to have such a letter written to him!'

If Maria was inclined to lose her nerve at the doctor's raging, with its dire pronouncement that he considered her 'no longer as his granddaughter', the effect on Constable was quite the opposite. Now that things had come to a head he braced himself to face the storm. It was not unexpected. 'I have always feared', he told Maria, '. . . that we were making ourselves happy over a barrel of gunpowder.' For him the doctor's outburst had helped to simplify the issue, and he wrote to Maria stating his conviction that 'our business is now more than ever with ourselves. I am entirely free of debt, and I trust, could I be made happy, to receive a good deal more than I do now by my profession. After this, my dearest Maria, I have nothing more to say, than the sooner we are married the better.'

But things were not quite as easy as all that. Maria had her father's feelings to consider, and for Constable there was the question of providing the necessary cash. Constable's father died in May 1816, so Constable's share of the estate would help to raise his income a little; but even at the most optimistic estimate the finances of marriage were going to be a tight squeeze. It was perhaps only natural that Maria should hesitate to exchange the comfort and security of her father's house for the hardships and uncertainties of art. She had once warned Constable that as a couple they would 'be bad subjects for poverty', and later she told him that 'people cannot live now upon £400 a year'. (In fairness to Maria, it should perhaps be pointed out that she was probably only quoting the kind of thing her parents had told her in order to make marriage with Constable seem less attractive.)

In spite of difficulties Constable pressed on in his determination to marry, and on 2 July he told Farington of his intentions. The next day his friend John Fisher was married in London, which no doubt seemed to Constable an additional reason for taking the plunge himself. Yet on Maria's side there were still doubts and hesitations and pleas for waiting longer. In the end it was Fisher who tactfully and firmly brought the lovers to the point of positive decision. In a letter from Osmington Rectory, dated 27 August 1816, he wrote: 'I am not a great letter writer: and when I take the pen in hand I generally come to the point at once. I therefore write to tell you that I shall preach at Salisbury on Sunday September 22nd on the occasion of an ordination: and that I intend to be in London on Tuesday evening September 24th. . . . And on Wednesday shall hold myself ready and happy to marry you. There you see I have used no roundabout phrases; but said the thing at once in good plain English. So do you follow my example, and get you

to your lady, and instead of blundering out long sentences about the "hymeneal altar" etc. say that on Wednesday September 25th you are ready to marry her. If she replies, like a sensible woman as I suspect she is, well, John, here is my hand I am ready, all well and good. If she says, yes, but another day will be more convenient, let her name it; and I am at her service . . . '

In the end Constable and Maria were married at the church of St Martin-in-the-Fields, London, on 2 October; and at Fisher's suggestion they spent their honeymoon with him at his rectory at Osmington in Dorsetshire. As it turned out, the marriage proved an extremely happy one. Mr Bicknell soon grew to approve of Constable as his son-in-law; and even the obdurate old Dr Rhudde relented sufficiently to leave Maria £4,000 in his will.

The Constables spent nearly two months with the Fishers in Dorset before returning to London by way of Salisbury and Binfield in Berkshire. For Constable this was one of the few extended periods of relaxation he was to enjoy before the trials and struggles of his professional life kept him virtually a prisoner in London. There was to be another long stay with the Fishers at Salisbury in the summer of 1820 which must have brought Constable much the same kind of happiness, but it was to Osmington ('dear old Osmington', as he calls it) that his thoughts so often turned in later years with nostalgic affection. Writing to Fisher in 1822 he says: 'How much I should like now to be at Osmington— but work I must and will. . . . If I recollect the ashes have very beautiful mosses and stems at Osmington.'

And in 1826: 'I at this moment hear a rook fly over my painting room in which I am now writing—his call transports me to Osmington and makes me think for a minute that I am speaking and not writing to you—it reminds me of our happy walks in the fields—so powerful is the voice of Nature.'

Back in London, Constable gathered up the threads of his art to make another bid for success and recognition. He was now master of the sketch, able to record skies and landscape with a perfection of touch which any artist might envy and few could hope to equal. But the public, as Constable knew only too well, were not impressed by perfection measured in inches. What they looked for and what the critics dutifully praised, was art on the grand scale, the assumption being that no modern picture could challenge comparison with the art of the past unless it had some claim to monumental proportions. It was, presumably, in deference to this view that Constable applied himself now to the treadmill of the six-foot canvas. In later years it was to be a desperate struggle for him to get these large works ready in time for the exhibitions at the Academy, and the effort they cost him increasingly undermined his health and spirits.

His first work on this ambitious scale was the picture known today as 'The White Horse', which was exhibited at the Academy in 1819 under the title 'A Scene on the River Stour' and is now in the Frick Collection, New York. At the exhibition it was favourably noticed by the Press, but found no purchaser till Fisher himself came forward as a buyer.

Fisher had written to Constable asking the price of the picture, but wording it in such a way that Constable supposed he was making the enquiry on behalf of someone else. Constable replied that the price of his painting was a hundred guineas, exclusive of the

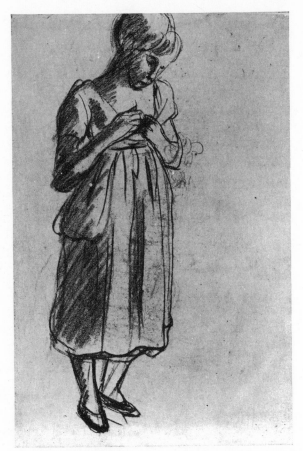

(iv) *A child threading a needle*

frame. Fisher then wrote to say that he wished to become the purchaser. Constable, on finding that Fisher wanted it for himself, offered to sell it for less, but Fisher generously refused to allow any paring of the price for friendship's sake. 'Why', he asks, 'am I to give you less for your picture than its price? It must not be.' So, for the first time in his life, Constable sold a landscape for a respectable sum.

Constable's next work on a large scale was exhibited at the Royal Academy in 1820. It was a painting of Stratford Mill on the Stour near Dedham and was later engraved by Lucas under the title of 'The Young Waltonians', a reference to the boys fishing on the river bank in the foreground. This picture, now in the collection of Major R. N. Macdonald-Buchanan, brought Constable a good deal of flattering notice when it appeared at the Academy under the simple title 'Landscape', but in spite of its favourable reception by the critics the painting remained unsold. Once again it was the generous patronage of Fisher that saved Constable from having a large picture left on his hands. This time Fisher proposed buying the painting as a present for his lawyer Tinney when a lawsuit that Tinney was conducting on his behalf had been won. In due course Fisher won his case and Constable put the 'Stratford Mill' back on his easel to retouch it before sending it to its new owner. Thanks to Fisher the time and effort expended on these large canvases had not been wasted, as Constable gratefully acknowledged: 'Believe me—

my very dear Fisher—I should almost faint by the way when I am standing before my large canvases was I not cheered and encouraged by your friendship and approbation.'

That was the point, of course. Apart from Fisher, who was there with perception enough to see the originality of his art? In the letter to Fisher quoted above Constable goes on to say: 'I now fear (for my family's sake) I shall never be a popular artist—a Gentleman and Ladies painter—but I am spared making a fool of myself. . . .'

Standing before his large canvases, he must have been haunted by the thought that the only public he could ever hope for was the circle of his own friends. Yet the next large picture he sent to the Academy was destined to extend his reputation in a way he could scarcely have imagined.

It seems that after completing 'Stratford Mill' he intended preparing for exhibition a large version of a subject he had been working on for some time, 'The Opening of Waterloo Bridge'. But on Farington's advice he turned his attention to another Stour subject, a landscape more in the manner of his 'Stratford Mill'. It was sound advice, for though he would have had the Stratford Mill picture left on his hands if Fisher had not stepped in, it had been very favourably noticed by the critics and it was the kind of subject that was coming to be recognised as characteristically his. This new painting was exhibited at the Royal Academy in May 1821 under the title 'Landscape—Noon'.[1] Fisher, however, who had probably seen a preparatory version of the picture, called it 'The Hay Wain', the name by which it has been known ever since.

The exhibition of 'The Hay Wain' was a pivotal event in Constable's career. For one thing it marked the beginning of the one period in his life of relative success and prosperity. But it was significant in a broader sense. It inaugurated a new movement in European art in which Constable's share, however one chooses to evaluate it, was important enough to place him indisputably among the great innovators.

When 'The Hay Wain' appeared at the Academy it was well received by the critics, although, as in the case of Constable's other large landscapes, it failed to find a buyer. But there was perhaps some augury of its future success in the fact that it was seen by the great French painter Géricault and by another Frenchman, Charles Nodier, who wrote a glowing account of it in a little travel book called *Promenade de Dieppe aux Montagnes d'Ecosse*.

After the exhibition at the Academy Constable transferred 'The Hay Wain' to the gallery at the British Institution where it was seen by Arrowsmith, a picture dealer from Paris. Arrowsmith made an offer for the picture, but only half the sum that Constable had originally asked. Constable reported this offer in a letter to Fisher dated 13 April 1822. 'I have a professional offer of £70 for it (without the frame) to form part of an exhibition in Paris—to show them the nature of English art. I hardly know what to do. . . .' In the end he decided not to let the painting go, though, as he confessed to Fisher, he did 'want the money dreadfully'. The fact was that he needed funds now to meet his growing expenses. He had taken a house at Hampstead for the summer months and was also about to move from Keppel Street, where he had gone soon after he was married, to occupy Farington's old house in Charlotte Street, vacant now through Farington's death. For Constable larger living quarters had become essential to provide

[1] Now in the National Gallery.

a home for his increasing family, and the additional place at Hampstead was considered necessary as a refuge from the growing unhealthiness of London. The expense of the two houses was a ruinous strain on Constable's finances; and the difficulties of getting the Charlotte Street house into habitable order, together with the worry of having sickness among his household, reduced him to a state of illness and exhaustion. The only consolation was that he could count on earning something from the commissions he had in hand for portraits and landscapes, the most important being an order from the Bishop for two views of Salisbury Cathedral. With characteristic consideration the Bishop proposed giving Constable part of the payment in advance.

By the beginning of 1824 Constable was emerging from his difficulties and was hard at work painting. Arrowsmith had turned up again to renew negotiations for 'The Hay Wain', and there was talk of his buying other pictures if Constable could be persuaded to part with them. In a letter to Fisher dated 15 April Constable reports the successful conclusion of a deal: Arrowsmith was to have 'The Hay Wain' and 'A View on the Stour' for £250, with a small painting of 'Yarmouth Jetty' thrown in to complete the bargain.

In a letter of the following month Constable writes: 'My Frenchman has sent his agent with the money for the pictures destined for the *French* metropolis, thus again are honours thrust upon me. The one was got ready and looks uncommonly well and I think they cannot fail of melting the stony hearts of the French painters. Think of the lovely valleys mid the peaceful farm-houses of Suffolk, forming a scene of exhibition to amuse the gay and frivolous Parisians.' And in the same letter he tells Fisher that he has sold his painting of a lock scene, exhibited at the Academy, for 150 guineas. After years of struggle the tide had at last turned for Constable and he was spared the necessity of carrying his 'dish between fame and famine', as Fisher had once phrased it. New orders for pictures for Paris came from Arrowsmith and also from Schroth, a French dealer whom Arrowsmith had brought with him on one of his visits to Charlotte Street. The new orders amounted to seven pictures which Constable was to have ready for Paris by August.

At this moment of relative success Constable looks back over the bleak years when Fisher alone supported and encouraged him, and he acknowledges with touching candour all that Fisher's friendship has meant to him. 'I do hope that my exertions may at last turn towards popularity—'tis you that have too long held my head above water. Although I have a good deal of the devil in me I think I should have been broken-hearted before this time but for you. Indeed it is worthwhile to have gone through all I have to have had the hours and thoughts which we have had together and in common.'

In the middle of May 1824 Constable took his family down to Brighton and stayed there a few days before returning to London. While at Brighton he must often have looked towards the French coast and wondered how his fortunes were shaping in the 'French metropolis'. Two years earlier Fisher had suggested a trip to Paris, and now with Paris so much in the news Fisher had written again insisting that Constable should spend a week with him there. The idea of a French visit must have simmered in Constable's mind, for he tells Fisher that 'a steamboat goes from Brighton to Dieppe'. But if Paris had seemed relatively near and accessible from the pier at Brighton, it was a

different story when Constable returned to London and got immersed again in the labours of his painting-room. With so much work on hand, particularly his French commissions, he could find no time for the lengthy journeys Fisher had proposed. Paris, in fact, had become the enemy of Paris as far as a visit was concerned. Commenting on his friend's refusal to travel, Fisher writes in bantering tone: 'In parson's language, I shall observe, that "I gather three things from your letter". First that you will *not* accompany me on the visitation: secondly, that you will *not* go to Paris: and thirdly, that you will *not* come to Gillingham.'

All the time Constable could spare for travelling was taken up in the coach journey from London to Brighton where he went whenever he could visit his family while they were staying there. When he returned to London he kept a journal which he posted down to his wife at intervals to keep her informed of his doings in Charlotte Street. In this journal he notes down the kind of details he thinks Maria will be interested in—what he has had to eat and drink, the people who have called, the balloon he and Fisher saw on their way from Pall Mall, the colour of the bonnets the Miss Fishers have brought back from Paris, and so on.

Monday, 14 June. Fisher had called on his way to the Charter House with his boxes, in a coach.

Tuesday 15 June. On getting to work, Fisher called and we met as usual delighted with each other. We chatted a great deal and then went down to the Exhibition. Returned to dinner, boiled mutton, and some nice sherry. Fisher's sisters are returned from Paris quite pleased.

Wednesday 16 June. A French gentleman[1] and lady called, to beg permission to see '*de* Gallery of Mr Constable'. They were much pleased, could talk a little English, and we got on very well. He ordered a little picture, and wished to know if I would receive any commissions from Paris where he said I was much known and esteemed, and if I would go there, the artists would receive me with great *éclat*. He was wholly struck and delighted with the picture of Tinney's—which now looks so very beautiful on the easel; it is of service to me to have such a good work to show. Jackson told me that Lord Fitzwilliam would certainly have bought my picture, if it had not been sold to Mr Morrison. Fisher called on me and had some dinner, a polony and bread and cheese, and sherry—we then had coffee and tea; and Leslie called to ask me to pass the evening. He stopped to tea and Mr Bigg called. Fisher and Leslie had a good deal of talk about Irving.[2] A new book of his is just out, I do not recollect the title— Fisher is quite pleased with him. Fisher says that Captain Basil Hall's travel in South America is a most interesting work.

Thursday 17 June. Came home and set to work on Fisher's picture—which I did very well. About half past one Fisher called. We had a nice leg of mutton ready at two, and after dinner and a glass or two of sherry we set off for Pall Mall, to the Gallery— and looked in at Christies. We saw there all Reinagle's collection of pictures and some copies by his son. We then went to the New Gallery—beautiful rooms, but the most

[1] The Vicomte de Theeluson.
[2] Washington Irving, the American author.

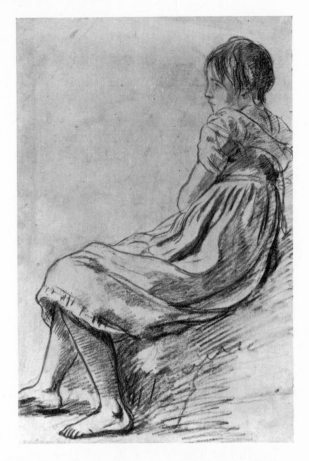

(v) *A country child*

wretched display of pictures that it is possible to conceive—nothing in the world can be worse. Saw the R.I.C. Judkin's[1] picture, 'Stolen Moments'—too bad and vulgar to look at. I called at Lady Dysart's in Pall Mall. We returned to tea and coffee, quite tired with our walk. On our way from Pall Mall at the top of the Haymarket we had a full view of the balloon—which looked so near that I could see the divisions of coloured silk. On its rising higher we saw it on a clear blue sky, looking like a golden egg—it then went into a white, thin cloud—and then emerged from it with great beauty, one side so very bright—and the other so clear and dark—looked till it was hidden by other clouds. After tea we walked round by Islington to the Charter House. Parted with Fisher at the gates, and returned by Holborn.

Friday 18 June. After dinner Fisher called. I was at work and had been all day—on the little Osmington Coast. Fisher was on a fasting plan today—but took coffee—he did not call till 6 o'clock evening. At tea time Peter Coxe[2] called. Johnny[3] said I was at

[1] The Rev. T. J. Judkin, a friend of Constable's, but an indifferent artist. Constable said of him: 'He is a sensible man . . . but he will paint.'

[2] Author. Constable had contributed a drawing of a windmill to Coxe's book *The Social Day*.

[3] Son of John Dunthorne who had been Constable's painting companion in the early days. Young Johnny acted as studio assistant to Constable.

Brighton, still he came in—and we heard him talking loud in the painting room. Fisher got up and locked the parlour door.

Sunday 20 June. Fisher took away his little picture of the Mill with a frame. He is quite anxious that I should dine there tomorrow or he says he shall have the party. I ought to be at the Artists Fund as it is a particular night. He spoke very much of the new novel, the Red Gauntlet, and was not the least surprised when I told him of Sarah[1]—he said she looked like it, and that her constitution was now impaired and she would never be well again.

Monday 21 June. Was not interrupted till 4 o'clock. Fisher came in determined that I should dine at the Charter House. I forgot to mention that about 2 o'clock Collins[2] called; he says I am a great man at Paris, and that it is curious they speak there of only three English artists, namely Wilkie, Lawrence, and Constable. This sounds very grand. He was quite struck with the look of Tinney's picture. He hopes it will go to the Gallery. Fisher was so determined that I should dine at the Charter House—but I was unwilling because I ought to have been at the Artists Fund. Collins however said there would be enough without me, so I went—about 4. The day at the Charter House was very pleasant. I met Dr Irvine, a good natured young man, and my old school friend Bob Watkinson, a lady—and the three Miss Fishers. Mrs and Dr Fisher were quite agreeable. The two younger were returned from Paris. There was a display after dinner of bonnets etc. etc. from Paris, which as they wore them passed the Custom House. They were very pretty—one pink, the other white. A Mrs Wolfe came in the evening. She is very pretty, and talks incessantly of all the arts and sciences. I did not leave the house till 12. I slept pretty well for so good a dinner. The dinner was salmon—and a quarter of lamb, veal stewed—and some savoury side dishes. 2nd course—large dish of green peas and 2 ducks—lovely puddings and tarts, beautiful dessert, and I drank only claret. We had good talk. Some of them stayed till 2.

Tuesday 22 June. Fisher called about 2 o'clock—dined with us on a new piece of roast beef. Walked with him to Pall Mall and to my bank. Had a letter from Paris. Mr Arrowsmith informed me of the safe arrival of my pictures, and how much they were admired; he talks of coming again the end of next month; I shall be ready for him; his letter is flattering, but I have no wish to go to Paris.

Wednesday June 23rd. Fisher came on his way to Piccadilly to the coach, so Judkin took his leave. I went with Fisher to the coach and we had dinner in the Coffee House—I drank ale and two glasses of brandy and water. He did the same. We parted quite delighted with having seen so much of each other—he longs like me to get to his darling wife and children.

June 24th. — called. He did not want to see me, but had something to say to a man he had with him, and if I would give him leave, would take him into the parlour. —He easily makes himself at home.

June 25th. After breakfast called on the Bishop by his wish. He had to tell me that he thought of my improving the picture of the Cathedral, and mentioned many

[1] A servant in Constable's household.
[2] William Collins, the artist.

things.—'He hoped I would not take his observations amiss.' I said: 'Quite the contrary, as his Lordship has been my kind monitor for twenty-five years.' I am to have it home tomorrow. He says I must visit the Colonel[1] at Charlton this or next month, for a day or two; I do not wish it, as I begin to be tired of going to school. The good Bishop has been at Dedham, and found the wretched —'s at daggers drawn. He reconciled them, and insisted on their shaking hands, which they did. Mr Neave called this evening about five. He is always the most agreeable person in the world. He was quite astonished at the picture on the easel (Tinney's), and hoped I would always keep to the picturesque, and those scenes in which I am 'so entirely original'. Mrs Hand tells me that Owen[2] always speaks so very highly of me, in every way, that it is quite delightful.

June 28th. F. Collins[3] called to ask me to a party, but Sir George Beaumont had sent me tickets for the British Institution this evening, and I thought it would be a treat to Johnny Dunthorne to see so many fine ladies.

June 30th. Sir George Beaumont called to know if I would undertake a singular commission. There is a lady who has devoted herself to the discovery of what is called the Venetian secret of colouring. She has been at it these twenty years, and has at length written to the Secretary of State to desire proper trials may be made of it by some eminent artists. Sir George asked me to try it, saying I should be paid for my time, etc. and thinking that, as the lady is now at Brighton, it might not be inconvenient to me. I shall see him again tomorrow; the lady's name I forgot.

July 1st. I am glad to find the lady who has discovered the Venetian secret declines submitting to any one artist. She wants the governors of the British Institution to send many artists, and to offer very high premiums for their success, so Sir George hopes there will be an end of it. Mrs — saw the Exhibition, and was delighted with my picture, which, she says 'flatters the spot, but does not belie nature'.

July 2nd. Received a letter from the Institution offering prizes for the best sketches and pictures of the Battles of the Nile and Trafalgar; it does not concern me.

July 3rd. Mr Ottley[4] called this morning. I was introduced to him by Sir George Beaumont. He was much pleased, and stayed a long time, and looked at a good many things. He is more of a connoisseur than an artist, and therefore full of objections. A good undoer, but little of a doer, and with no originality of mind. He invited me to drink tea with him. —Mr Appleton, the tub-maker, of Tottenham Court Road, called to know if I had a damaged picture which I could let him have cheap, as he is fitting up a room up one pair of stairs. . . . Went to tea with Mr Ottley. Saw some beautiful prints. Such a collection of Waterloo's etchings, I never saw. There was also an abundance of his own things, which gave me a great deal of pain; so laborious, so tasteless, and so useless, but very plausible. They were all of the single leaf, and chiefly laurels, weeds, hops, grapes, and bell vines; and ten thousand of them. He is a very clever writer and a good man. He says he has lost a great deal by his publications on art.

[1] Sir George Bulteel Fisher, an amateur landscape artist.
[2] William Owen, portrait-painter.
[3] Frank Collins, brother of William Collins, the artist.
[4] William Young Ottley, writer and art collector.

c

July 7th. Took tea with Rochard.[1] The Chalons[2] and Newton[3] there. A pleasant evening. Saw in a newspaper on the table a paragraph mentioning the arrival of my pictures in Paris. They have caused a stir, and the French critics by profession are very angry with the artists for admiring them. All this is amusing enough, but they cannot get at me on this side of the water, and I shall not go there.

July 10th. Dressed to go to Leslie's to dinner. It is a very fit house for an artist, but sadly out of the way. But it is quite in the country. Willes and Newton there. After dinner took a walk in the fields and to the new church, St John's Wood, where my poor uncle, David Pike Watts, is buried. Saw the tomb. A lovely evening.

The contents of this journal give some hint of the kind of news Constable must have talked over with Maria when he finally rejoined his family at Brighton on 17 July. Presumably the lady who claimed to have discovered the Venetian secret and who was staying at Brighton faded into obscurity, though we may perhaps regret that Constable never made her acquaintance. Had he done so he might have left us a description of her as amusing as the one he gave of another lady of similar artistic pretensions whom he met at dinner at the Bishop's house in Seymour Street earlier in the year, a certain Mrs MacTaggett who was tactlessly presented as a 'lady paintress with whom I should be much pleased'. 'As I expected,' Constable tells Fisher, 'I found a laughing, ignorant, vulgar, fat, uncouth old woman, but very good-natured and she gave me no trouble at all as she wanted no instruction from me. When she told me of an oil proper for painting I told her it would not do—but she assured me it would and she could give me no greater proof of it than that one of *her* pictures was entirely painted with it.'

But like Mrs MacTaggett and the lady who believed she had discovered the Venetian secret, the Bishop himself had his own particular theories about art. As Constable records in his journal, he was summoned to Seymour Street to discuss ways of 'improving' the picture of Salisbury Cathedral which he had painted for the Bishop. What his Lordship principally objected to was the presence of a dark cloud behind the Cathedral (the Bishop always liked his skies to be clear), and Constable had to reconcile himself either to painting out the offending cloud or to producing a new picture altogether. Characteristically, he chose the latter course, though it meant taking on another commitment at a time when he was already overburdened with commissions. In a letter written to Fisher the day after his arrival in Brighton he says: 'I have been long attempting to write to you—but in London I have so many occupations and interruptions, that I was glad to put it off till arrived here—whither I am come to seek some quiet with my children. I am harassed with a number of small commissions which greatly annoy me and cut into my time and consequently into my reputation. . . .'

Constable had timed his arrival in Brighton so that he was there for the birthday of his favourite daughter, Maria Louisa, or Minna as she was called by the family. On the evening of her birthday, 19 July, he painted his magnificent sketch, 'Brighton Beach,

[1] Either S. J. Rochard or F. T. Rochard, two brothers who had come over from France a few years earlier and were now working in England as miniature painters.
[2] The artist brothers A. E. and J. J. Chalon.
[3] Gilbert Stuart Newton, nephew of the American painter Gilbert Stuart.

with Colliers'. On the back of this sketch he has written the following notes, presumably for Fisher to read at some later date: '3d tide receding left the beach wet—Head of the Chain Pier Beach Brighton July 19 Evg., 1824. My dear Maria's Birthday Your God-daughter—very lovely Evening—looking Eastward—cliffs and light off a dark grey effect—background—very white and golden light. Colliers on the beach.'

A month before this sketch was painted Arrowsmith had written from Paris to report that the first consignment of Constable's paintings had created a sensation there. In the letter already quoted which Constable wrote to Fisher on the day after his arrival in Brighton, he gives a resumé of the kind of things the critics have been saying about his pictures and at the same time makes it clear that he finds the critics across the Channel as pompously prejudiced as their English counterparts: 'The French critics have begun with me and that in the *usual* way—by a comparison with *what has been* done. They are angry with the artists for admiring these "pictures which have made so much noise in Paris—and which they shall now proceed to examine"—etc. etc. They acknowledge the effect to be rich and powerful—and the whole has the look of nature, and colour (their *chief excellence*) to be rich and true and harmonious—but shall we admire works so unusual for these excellencies alone—what is to become of the great Poussin—etc. etc. Is this the only excellence to be looked for in the art of landscape painting—they then caution the younger artists to beware of the "seduction", those English works cannot fail to produce, when "exposed"—etc. etc.'

Yet in spite of the warnings and admonitions of the French critics, Constable's paintings continued to be the talk of Paris. When finally 'The Hay Wain' and 'A View on the Stour' were exhibited at the Louvre[1] they became so much the focus of attention that they were removed from their original positions and given a place of honour. There was talk too of 'The Hay Wain' being bought for the French nation, but Arrowsmith refused to sell it separately, insisting that Constable's two large paintings must be purchased as a pair, the price asked being £500 for the two.

The climax of Constable's triumph came when the King of France awarded him a gold medal for his landscapes in the Louvre. But apart from the official recognition, there was the satisfaction of knowing that his pictures had set all the French students of landscape thinking, and that as a tribute to his influence painters would exclaim, when about to start a landscape, 'Oh, this shall be—*à la* Constable!'

Success in Paris brought material rewards as well. In a letter of April 1825 Constable tells Fisher: 'I am fulfilling many orders in small for Paris—Mr Schroth 3 more—M. Didot [the great printer] 3—Mr Arrowsmith 2—etc. etc.—these all make income.'

While his fame was accumulating in Paris Constable was at work on the most dramatic and impressive of all his Stour paintings, the picture known now as 'The Leaping Horse', which was exhibited at the Academy in 1825.[2] With 'The Leaping Horse' Constable exhibited two replicas of the Hampstead views which he had sold to Schroth. Both these exhibits were bought, but 'The Leaping Horse', repeating the history of so many of Constable's other large landscapes, remained unsold. After the exhibition Constable

[1] A view of Hampstead by Constable was also exhibited.
[2] The full-sized sketch for this picture is now in the Victoria & Albert Museum and the exhibited version belongs to the Royal Academy.

put the picture back on his easel and made alterations to it, which suggests that the public may have found the original composition too forceful and disturbing.[1]

It is a pity that Constable never sent 'The Leaping Horse' to Paris where it might have caused an even greater stir than 'The Hay Wain'. His relations with Arrowsmith, however, which had begun so propitiously, came to an end in the autumn of 1825. Constable took exception to something Arrowsmith had said at one of their meetings in the Charlotte Street studio, and as a result Constable refused to have any more dealings with him. Though the quarrel was quickly patched up by an apology from Arrowsmith and a subsequent offer by Constable to let him have any other pictures he might want, no further business was done between them. In the end Arrowsmith sold 'The Hay Wain'— 'the old home', as Constable called it—for £400. In giving this news to Fisher, Constable concluded his letter: 'Arrowsmith has a room in his house called Mr Constable's room—I shall contribute no more to its furniture. He says my landscapes have made an epoch there.'

The end of the chapter came with rumours of Arrowsmith's impending bankruptcy. Schroth, who might have taken his place as a regular buyer for the Paris market, went out of business shortly afterwards. So the link between Charlotte Street and Paris was broken, never to be renewed.

It is unfortunate that Constable never thought it worth his while to seek new contacts with other Paris dealers or to follow up in any way the artistic epoch he had created there. His last gesture to the Continent was to send Fisher's picture 'The White Horse' to an exhibition held at Lille in August 1825. After that he seems to have forgotten altogether his triumph at the Louvre and the flattering things Frenchmen had said of him. Perhaps the reason was the low opinion he had of the French in general (the battle of Waterloo, it should be remembered, was still recent history), or perhaps seeing what he took to be signs of growing popularity among his fellow-countrymen, he believed that in a short time the demand for his paintings at home would absorb all his energies and make commitments to French dealers an unnecessary burden. Later, when this popularity failed to materialise, he must have often wished that there still existed somewhere in Paris a 'Mr Constable's room'.

The break with Arrowsmith marked in fact the end of Constable's one period of relative success. The years that followed brought not only their share of personal grief and loss, but also the growing realisation that his work would never really please the public. There were of course the occasional sales of smaller landscapes to buoy him up, but he must have felt, as he saw the unsold canvases accumulating in his studio, that his dream of winning English praise had now become a forlorn hope.

In the spring of 1825 Constable's 'kind monitor' the Bishop of Salisbury died. Constable felt the loss deeply. Though they hadn't always seen eye to eye in the matter of art, Constable could never forget the Bishop's kindness to him as a young man, and the indifference of the public made him cling more closely to the friends who had helped and encouraged him in the early days. The Bishop was very much in his thoughts when he painted his landscape 'The Glebe Farm'. 'My last landscape', he says, 'is a cottage

[1] This theory is borne out by the existence of a still more placid version (in the possession of the Willoughby family) where there is no leaping horse at all.

scene—with the Church of Langham—the poor Bishop's first living . . . I have "pacified it"—so that it gains much by that in tone and solemnity.'

The Bishop had always been one of those who found Constable's art a little raw, and in 'pacifying' 'The Glebe Farm' Constable probably had in mind his dead friend's preference for tone and finish in a picture. But the Bishop was not alone in finding Constable's vigorous style difficult to appreciate. The critics and the public consistently jibbed at what seemed to them his lack of finish. Constable himself knew their objections well enough. 'My art flatters nobody by *imitation*, it courts nobody by *smoothness*, it tickles nobody by *petiteness*, it is without either *fal de lal* or *fiddle de dee*, how then can I hope to be popular?'

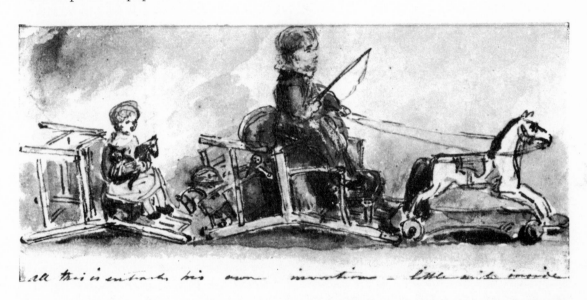

(vi) *The artist's children at play—probably John Charles Constable and Maria Louisa Constable. Ink and water-colour. Inscribed by the artist: 'All this is entirely his own invention—the little mite inside'.*

But in 'The Cornfield' (now in the National Gallery), which was painted in the same year as 'The Glebe Farm', 1826, he made a special effort to please the public. 'I am much worn, having worked very hard—and have now the consolation of knowing I must work a great deal harder, or go to the workhouse. I have however work to do—and I do hope to sell this present picture—as it has certainly got a little more eye-salve than I usually condescend to give them.' Yet in spite of the 'eye-salve' the picture was not sold.

In 1827 Constable exhibited at the Royal Academy a large painting of 'The Chain Pier, Brighton' (now in the Tate Gallery). Here again he had taken special pains over detail and finish, but the critics condemned it roundly. This picture was the fruit of his visits to Brighton where he had taken his wife and family in search of health. Added to the worries of his work, there was now a growing anxiety over Maria's health. On that

account he had decided to move his household from London to a permanent home in Hampstead, keeping only a few rooms in Charlotte Street for his own use. 'My plans in search of health for my family have been ruinous,' he tells Fisher in a letter asking for a loan to help pay the expenses of the Hampstead move. Fisher, however, was too low in funds himself to offer anything but a nominal sum. In the end Constable's money difficulties were unexpectedly solved by the death of his father-in-law, old Mr Bicknell, who left a fortune greater than anyone had guessed. 'I shall stand before a 6 foot canvas with a mind at ease (thank God)', he could say at last.

But though his financial difficulties were eased, there was still the greater worry of Maria's health upon his mind. In a letter dated 11 June 1828 Constable tells Fisher: 'My wife is sadly ill at Brighton.' Mortally ill, he must have feared. Maria rallied a little when brought back to Hampstead, but died there of consumption on 23 November. For the rest of his life, we are told, Constable never wore anything but mourning.

Constable's remaining years were devoted to the care of his seven children and to the unflagging practice of his art. In happier days he had once said: 'I have a kingdom of my own both fertile and populous—my landscape and my children. I am envied by many, and much richer people.' The loss of Maria made this kingdom doubly precious now. The fact that at this stage of his life he was elected at last a full member of the Royal Academy gave him more pain than satisfaction. After years of cold-shouldering and rebuff he was finally elected by the unflattering margin of a single vote. Sir Thomas Lawrence, President of the Academy, was less than tactful in telling him he was lucky to be elected at all, seeing there were historical painters of greater merit on the list. In view of the squalid manoeuvring that had frustrated Constable's election in earlier years, Fisher was certainly justified in calling it 'the triumph of real Art over spurious Art . . . of patient moral integrity over bare chicanery.'

Under the shadow of Maria's death Constable painted in 1829 one of his supremely great pictures, the sketch of 'Hadleigh Castle' now in the Tate Gallery. Painted almost entirely in sombre tones of blue and grey, it has a power and freedom of technique which make it seem even today essentially modern. But it is more than a pioneer example of Impressionism. The decay and desolation which he paints so powerfully are symbols of his own despairing mood, his sense of nature as a force of dissolution. The grey immensity of sea and sky dwarf human life as personified by the figure of the shepherd in the foreground, and the strongest work of man, the once massive and seemingly impregnable castle, has been reduced to pasteboard frailty by the action of time and weather. As an expression of a fatalistic philosophy, it compares with Van Gogh's last paintings of deserted fields under vast and brooding skies.

Constable paid his last visit to Fisher at Salisbury in November 1829. The company of his old friend may in the end have helped to cheer his spirits, for the large painting of 'Salisbury Cathedral from the Meadows',[1] exhibited at the Academy two years later, is lit by a magnificent rainbow, the symbol of hope.

A year after this picture was exhibited John Fisher died of cholera at Boulogne, on 24 August 1832. So ended a friendship which Constable once called 'the pride—the honour—and grand stimulus of my life'.

[1] Now in the collection of Lord Ashton of Hyde.

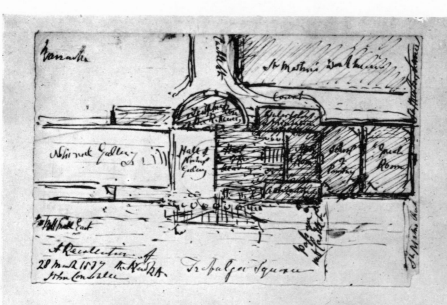

I called on Constable on March 28th 1837. he was
then working on his "Arundel Castle", and
seemed well satisfied with the result of
his labours, he said while giving a touch
here and there with his Palette knife, and
retiring to see the effect, "it is neither too
warm, nor too cold, too light not too dark
and this constitutes every thing in a Picture,"

I dined with him, and in the evening on my
asking him about the then news R.A. he took a pen
and sketched the above plan, signed and
gave it to me,

He died on the 31st three days after. see his life
page 113.
A.T. Dec 8th 1838

(vii) *Plan of the National Gallery building given by Constable to Alfred Tidey.*[1]

After Fisher's death his place was taken to some extent by another friend, a namesake of Constable but no relation—George Constable of Arundel. Constable paid several visits to him there, and in latter years the landscape of Sussex came to mean as much to him as the countryside of Salisbury had once done or the green banks of the Stour. But it was his biographer, the American artist C. R. Leslie, who succeeded best in re-establishing the kind of relationship that Constable had once shared with Fisher. Leslie was a man of outstanding charm, and his integrity and warmth of heart seem to have won Constable's confidence from the start. As a fellow-painter he could share Constable's artistic world in a way that Fisher never quite did, exchanging those items of professional gossip which Constable so much relished. At the close of his life, in an invitation to dine, it is to Leslie, as to a kindred soul, that Constable repeats the last words of invitation he received from Fisher: 'Prithee come, *life is short, friendship is sweet*'.

Appropriately, it is Leslie who gives us our last glimpse of Constable the man, a touching and characteristic glimpse.

'On Thursday, the 30th of March (1837), I met him at a general assembly of the Academy, and as the night, though very cold, was fine, he walked a great part of the way home with me. The most trifling occurrences of that evening remain on my memory. As we proceeded along Oxford Street, he heard a child cry on the opposite side of the way; the griefs of childhood never failed to arrest his attention, and he crossed over to a little beggar girl who had hurt her knee; he gave her a shilling and some kind words, which by stopping her tears, showed that the hurt was not very serious, and we continued our walk.—Some pecuniary losses he had lately met with had disturbed him, but more because they involved him with persons disposed to take advantage of his good feelings, than from their amount. He spoke of these things with some degree of irritation, but turned to more agreeable subjects, and we parted at the west end of Oxford Street, laughing—I never saw him again alive.'

The whole of next day, Leslie tells us, Constable was busily engaged in finishing his picture 'Arundel Mill and Castle.'[1] Our last glimpse of Constable the painter comes from a fellow-artist Alfred Tidey[2] who visited Charlotte Street while Constable was at work on this picture. 'I called on Constable on March 28th 1837', Tidey records. 'He was then working on his "Arundel Castle", and seemed well satisfied with the result of his labours. He said while giving a touch here and there with his palette knife, and retiring to see the effect, "It is neither too warm nor too cold, too light nor too dark, and this constitutes everything in a picture".

'I dined with him, and in the evening, on my asking him about the then new R.A., he took a pen and sketched the above plan, signed and gave it me. He died on the 31st, three days after.'

[1] Now in the Toledo Museum of Art, Toledo, Ohio.
[2] Miniature painter, 1808–92.

Constable and
the Romantic Vision

OF all English artists Constable, it seems to me, was one who never compromised his art or sacrificed his principles for the sake of popularity. And he alone among English painters has an undisputed place in the history of European art.

There is Turner, of course, and no fair-minded critic can deny his genius. He is one of those painters who at their greatest extend the frontiers of art, and the word 'Turner-esque' sums up an epoch of romantic feeling. Yet for all that there are reservations to be made. When one considers critically Turner's vast *œuvre*, the huge mass of work done over a long and fanatically industrious life, how many things one wishes for the sake of his reputation had been left undone! In a way his colossal ability was his undoing, coupled as it was with an overriding ambition to copy and surpass the old masters in their own style. In his excursions into classicism and his braggadocio emulation of Claude, Turner challenged comparisons that show all too clearly his intellectual weakness. Constable made no such mistake. He too admired Claude, but was content in a spirit of humility to learn from him. He had no desire to paint classical subjects or to challenge the old masters by a direct imitation. A core of rustic common sense kept his feet firmly planted on the ground. He was, one might say, provincial in the sense that George Eliot and Cézanne were, and his strength derived from an intimate knowledge of the landscape he chose to paint. The very Englishness of his art has tended to blind us to its element of universality. When he paints a lock on the Stour or a view of Salisbury Cathedral he is doing more than depict a particular scene: he is embodying in the picture his personal philosophy which was also the artistic philosophy of the age. That is the important thing to remember. Constable was a Romantic and to understand him one has to understand the artistic climate of his time. Throughout his life his aim was truth to nature, not truth in the photographic sense as we tend to think of it now, but truth as a kind of dual vision in which the outward forms of nature were seen as imbued with a spiritual significance, that 'something far more deeply interfused' of which Wordsworth so eloquently speaks. Constable, we know, was an admirer of Wordsworth's poetry and like Wordsworth a believer in the revelationary power of nature. For both men nature in her humblest forms, in leaves, in grass, in hedgerow flowers, could yield to the perceptive mind her flash of vision. For Constable a poppy or an ash tree was not merely one of a species: it was at the moment when he painted it something individual and unique. This helps to

41

explain the freshness of his art and why after this lapse of time a landscape by him can produce the same shock of surprise that one gets when a fine view is suddenly revealed by the drawing of a curtain.

The philosophy that Constable and Wordsworth shared was not a new one, nor was it exclusively Western. A Hindu reading Wordsworth would understand his intent. By a curious chance the romanticism of the early nineteenth century had an affinity with Eastern thought, the common ground being the English feeling for nature, with its mystical trends and its leanings towards pantheism. This feeling for nature, and the poetry and landscape painting it produced, have been England's greatest contribution to European art. For a parallel one has to go to the landscape art of ancient China where natural forms were seen as manifestations of the Universal Spirit. Truth to nature meant for the Chinese not only a linear representation of a leaf or mountain, but also a recognition of its inner character, its true identity in relation to the *Tao*, or Cosmic Spirit, of which it was both a manifestation and a part.

'To learn to draw a flower', says Kuo Hsi, the great artist of the Sung period who was born about 1020, 'it is best to place a blossoming plant in a deep hollow in the ground and look down upon it. Then all its qualities may be grasped. To learn to draw bamboo, take a branch and cast its shadow on a white wall on a moonlight night; then its true outline can be obtained. To learn to paint landscape, too, the method is the same. An artist should identify himself with the landscape and watch it until its significance is revealed to him.'

The painting of landscape at every season of the year and under every variation of atmosphere and weather could lead to a profounder understanding of its spiritual significance. Kuo Hsi gives us a list of subjects suitable for painting.

'Spring themes may be selected as follows', he says. 'Clouds of early spring; early spring rain; early spring with snow; clearing after the spring snow; clearing after the spring rain; a misty spring rain; chilly clouds of early spring about to turn into rain; an evening of early spring; sunrise over the spring mountains; spring clouds about to turn into rain; the mist and haze of early spring; spring clouds rising out of the valley; the dance of spring on the swollen stream; spring rain blown aslant by a spring wind; clear and beautiful spring mountains. . . .

'For summer these themes may be chosen: the lifting of the mists over the summer mountains; summer mountains after rain; wind and rain on summer mountains; morning walks in summer mountains . . . rain passing over summer mountains; clouds heavy with rain; a swift wind and sudden showers or a sudden wind and swift rain; a rain-storm ending over the summer mountains; returning of the clouds; dashing torrents after the summer rain; misty dawn over the summer mountains; misty twilight over summer mountains; a mountain retreat in summer; cumulus clouds in the summer sky. . . .'

If one substitutes for the word 'mountains' the general term 'landscape', one has an almost complete list of the subjects Constable chose to paint.

We may be pretty certain that Constable never saw a Chinese landscape painting and equally certain that had he done so he would have found the rigid stylization uncongenial. What he would have understood, however, was the artist's mode of feeling,

the vision that saw in the forms of nature an expression of a spiritual law and rhythm which governed the universe.

In his lifetime people complained that Constable always painted the same subject, a criticism that can be brought against a number of other great painters. The fact is, of course, that any painter or any writer tends to create his art from the material that moves him most, and as often as not it is from the surroundings and experiences of his early years that the germ of inspiration springs. Environment is the seed-bed of ideas. Some minds have achieved greatness in art not by straining at horizons, but by narrowing their range in order to understand profoundly a single fragment of locality. Dante, Cézanne, Dickens, Constable—all were geniuses of place.

For Constable it was the river Stour and the East Anglian countryside—'the lovely valleys and peaceful farm-houses of Suffolk', as he puts it—that were the inspiration of his art. 'Painting is with me', he writes, 'but another word for feeling, and I associate "my careless boyhood" with all that lies on the banks of the Stour; those scenes made me a painter, and I am grateful; that is, I had often thought of pictures of them before I ever touched a pencil.'

Constable's preference for certain themes was based on an instinctive understanding of his own psychology. It needed the power of long association to bring his mind into creative sympathy with a scene. To see was not enough; he had also to feel and to know a landscape from the inside. Unlike Wordsworth, he found no inspiration in solitude or the wild grandeur of mountains. He preferred landscape that was familiar to him through its human association and the special knowledge that comes from personal experience of a locality. He was in fact unknowingly following the advice of Kuo Hsi already quoted: 'An artist should identify himself with the landscape and watch it until its significance is revealed to him.'

What the critics did not understand was that for Constable it was never the same picture that he painted. He might repeat a subject, but the visual experience underlying it was different, therefore the picture itself was different too. As he himself puts it: 'The world is wide; no two days are alike, nor even two hours; neither were there ever two leaves of a tree alike since the creation of the world; and the genuine productions of art, like those of nature, are all distinct from each other.'

In nature there was no repetition, only a continual process of revelation through the infinite changes of atmosphere and light, and the artist who looked into nature and not merely at her could extract from her continuum of truth a moment of enduring vision.

It was this capacity of Constable's to see below the surface which impressed the visionary Blake. C. R. Leslie records that Blake, when looking through one of Constable's sketch-books, said of a beautiful drawing of trees: 'Why, this is not drawing, but *inspiration*.'

Constable did not take this reference to inspiration as a compliment to his art and merely replied, 'I never knew it before, I meant it for drawing'. Blake with his psychological insight into such things was probably nearer the truth than Constable guessed. Constable, we must remember, was no revolutionary, and for him the words 'inspiration' and 'enthusiasm' were suspect terms, suggesting the unorthodox forms of religion and

43

the dissenting sects, which he saw as dangerous threats to the established order. His feeling for nature never led him outside the bounds of a traditional religion. Rather, he saw in nature a reinforcement of his own religious beliefs and a convincing argument for the essential truth of Christianity. Ruskin, who shared Constable's philosophy of nature but perversely failed to appreciate his art, has a passage which shows how easily the Romantic mind could identify a vision of the physical world with the religious experience.

'The woods, which I had only looked on as wilderness, fulfilled, I then saw, in their beauty, the same laws which guided the clouds, divided the light, and balanced the wave. *He hath made everything beautiful in his time*, became for me thenceforward the interpretation of the bond between the human mind and all visible things; and I returned along the wood-path feeling that it had led me far;—Farther than ever fancy had reached, or theodolite measured.'[1]

Constable himself is more explicit. In a letter to his wife in May 1819 he writes: 'Everything seems full of blossom of some kind and at every step I take, and on whatever object I turn my eyes, that sublime expression of the Scriptures, "I am the resurrection and the life", seems as if uttered near me.'

In his simple, unrhetorical way Constable goes deeper than Ruskin, and the note of mysticism is unmistakable. Constable, of course, would have jibbed at the word mysticism, while Blake and Samuel Palmer would have accepted it unhesitatingly. The difference is instructive. The mysticism of Blake and Palmer was a curious mixture of literary image and original art, a vision that didn't derive from nature but was projected into her, hung, so to speak, on preconceived forms. Their aim was not to paint nature as she was, but to re-create her in terms of their own religious experience, an undertaking which Constable would have regarded as vain and presumptuous. Like Constable, they believed in a spiritual reality behind material forms, but for them everything hinged on the personal vision and the clairvoyant faculties. Instinctively they thought in terms of seers and prophets, and in their art they transformed the green landscape of England into a biblical land glowing with mystic corn and lit by strange apocalyptic suns or moons. It was Romanticism and religion openly allied. Sometimes, admittedly, their mysticism is too consciously manipulated and a note of theatricality creeps in, but at its best the art of Blake and Palmer has a purity of vision which reminds one of the early Italian painters.

It was a misfortune for English art that Palmer was compelled to sacrifice his originality for the sake of getting a bread-and-butter living. In the end the social and artistic pressures of his age squeezed him into conformity and the vision faded.[2] Thus when Constable died there was no one to give new life to the landscape tradition. Constable himself in a moment of gloom in 1822 had prophesied: 'The art will go out—there will be no genuine painting in England in 30 years.' Actually he was being over-optimistic. With the exception of Turner and a few of the water-colourists, genuine painting in England had disappeared in less than twenty years. Only the Pre-Raphaelites were left

[1] John Ruskin, *Praeterita*.
[2] Since writing this, an extensive study of Palmer's work after the Shoreham period has convinced me that he remained all his life an extremely sensitive and perceptive artist and that the rather garish type of art associated with his later years is not by any means the whole story.

44

(viii) *Dedham Lock Mill and Church. Drawing for the painting in the Victoria and Albert Museum. Inscribed 'June 1820'*

to play a last and not very impressive card. The fact is that the Romanticism of the early nineteenth century owed a great deal to the artistic tradition and discipline of the eighteenth. When that influence waned the subtle balance of reason, emotion and imagination collapsed and a tide of sentimentality set in. Perhaps only in ancient China have the highest standards of art been sustained over a number of centuries. In the West thought has changed far more quickly, and its art, in comparison with that of the East, has expressed itself in a vast variety of styles, though each of relatively short duration. Indeed the time-phase has been so much the determining factor in European art that changes in aesthetic style reflect the changes of life and habit almost as accurately as do the pages of social history. It is probably true to say that Constable could only have painted as he did in that particular period of time in which he happened to be born. Had he lived earlier he would have missed the liberating influence of Romanticism, and had he come later he could not have achieved in quite the same way that interfusion of the traditional and the new which gives his art its characteristic balance and authority.

The span of Constable's life, the period between 1776 and 1837, was a time of far-reaching change. The industrial democracy that we know today was coming into existence, while the old order which it was soon destined to replace—the old world of squires and aristocrats—was still virtually intact. Constable was able to take simultaneously, so to speak, the backward and the forward view, to be a traditionalist living

under the stimulus of a revolutionary age. Though he deplored many of the political changes he saw, artistically he was no conformist. Had he been, he would have been content to go on working in the pastoral tradition of Wilson and Gainsborough, and to have pushed no further. As it was, his response to nature was so immediate and personal that even the traditional elements in his art, the technical methods he had learnt from his predecessors, received a new force and validity from the freshness of his vision. To many of his contemporaries he seemed no more than a dangerous and wilful innovator, a view that must have owed something to his caustic tongue and his bitter outbursts against the mediocrity of the Academicians. 'I have to combat from high quarters, even from Lawrence,' he writes, 'the plausible argument that *subject* makes the picture.'

Constable, the traditionalist and admirer of the old masters, was, when it came to the point, a staunch supporter of the new as opposed to the outworn and conventional. He knew from his own experience how obstinately the public clung to accepted ideas and what a fatal attraction old paint and yellow varnish had for the majority of 'connoisseurs'. His objection to the founding of a National Gallery was based on the fear that it would lead artists to produce pastiche rather than original work, misgivings which seemed amply justified by the quality of the paintings exhibited at such places as the British Institution and described by Constable in a letter to John Fisher dated 31 October 1822. '. . . Could you see the folly and ruin this day exhibited at the Gallery you would go mad. W. Vanderveld—and Gaspard Poussin—and Titian—are made to spawn millions of abortions. . . .'

In an earlier part of the same letter he makes it clear to what extent the art of the old masters can be of service to succeeding generations. It is not, he insists, a question of direct imitation, but of using the experience of the earlier painters to strengthen the art of their successors, so that they may 'get at Nature more surely', as he puts it. His own art was strengthened in its turn by the experience of Claude and Poussin, of Rubens, Gainsborough and the Dutch landscape painters. Constable was traditional in the sense that all truly original painters are—even such seeming iconoclasts as Cézanne and Van Gogh. What appears new and startling in their work has actually behind it all the authority of tradition and that reverence for the past without which no artist ever produced anything significantly new.

Constable says of Gaspar Poussin that his works 'contain the highest feeling of landscape yet seen—such as union of patient study with a poetical mind'. It might be said that Constable's own art springs from such a union, and that without his patient studies of skies and trees the power and freedom of his later style could not have been so successfully achieved. Even in his use of the palette-knife there is no sacrifice of truth, and his 'impressionism' is in its way as close to nature as a meticulous copy.

The 'poetical mind' that he recognized in Poussin was for Constable an essential attribute of the true landscape painter. He was thinking of 'poetical' not in the strictly literary sense but rather as implying the particular kind of sensibility that interprets nature through feeling rather than intellect, the sensibility that responds emotionally to the subtleties of light and shade, to form as seen in relation to the atmosphere surrounding it. It was this quality of poetic feeling which Constable admired so much in Poussin and

Claude, in Wilson and Watteau, and in the water-colourist J. R. Cozens ('all poetry', as he called him). He could also, at moments when he shed his prejudices, admire it whole-heartedly in Turner. 'Turner has some golden visions', he writes, 'glorious and beautiful; they are only visions, but still they are art and one could live and die with such pictures.'

But the visions and the poetic sensibility were of no account without a patient study of nature herself. 'We see nothing truly till we understand it', Constable once said. All his life his aim was truth to nature through an understanding of her forms. Today the phrase 'truth to nature' means little to us except perhaps in the sense in which we might apply it to a successful outdoor photograph. But to such men as Constable, Coleridge and Wordsworth it had a profounder significance. For them nature was not haphazard or neutral in the sense that modern philosophy postulates. Rather, they saw her as a divinely created system, a mirror in which man could glimpse for a moment through the imaginative faculties the transcendent perfection to which he was ordinarily blind. When Coleridge writes:

> So will I build my altar in the fields,
> And the blue sky my fretted dome shall be . . .[1]

he is expressing a metaphysic that goes deeper than mere nature-worship. Nature was not in herself an absolute, but rather the prism in which the broken lights of truth could be discerned through the power of the imagination. Wordsworth to an even greater extent was inspired by this sense of 'otherness' in nature and projected his own feelings into her with no sense of incongruity.

> To every natural form rock, fruit or flower
> Even the coarse stones that cover the highway
> I gave a moral life.[2]

For both poet and painter the imagination is the only faculty by which the truth of nature can be perceived. Constable complains that the French art students do not understand this and copy nature too pedantically. 'They make painful studies of indivi-dual articles [he writes]—leaves, rocks, stones, trees, etc. etc., singly—so that they look cut out—without belonging to the whole—and they neglect the *look* of nature altogether, under its various changes.'

What he objects to is not the making of studies (he himself constantly did it), but the lack of art and imagination displayed in the use of them. Truth to nature, as Constable conceived it, demanded more than visual accuracy. It required humility in the observer and a combination of imagination and poetic feeling. Of Constable's French contempor-aries only Corot, perhaps, felt about nature in much the same way as Constable did; and with Corot the resemblance to Constable did not last much beyond the 1840s. After that date Corot's Romanticism ceased to be a matter of imaginative perception and became merely the tasteful painting of romantic scenes: silvery landscapes where gossamered nymphs dance at the edge of pools or among the shadows of the birch thickets. It is nature, one feels, seen through a boudoir window. A fragile charm has replaced the broad and sensitive touch of the earlier years when the influence of English landscape painting, particularly that of Constable and Bonington, served as an inspiration.

[1] Samuel Taylor Coleridge, *To Nature.*
[2] William Wordsworth, *The Prelude*, Bk. III.

47

It is difficult for us to realize now that the Romantic naturalism of Constable's art was regarded by most of his contemporaries as crude and revolutionary. And it is equally difficult to realize that what seems to us a simple statement of fact, a landscape painted in naturalistic tones, is in Constable's case as much an expression of religious feeling as the pious art of the early Italian masters. The philosophy of Constable's day identified virtue with the pastoral life and saw in nature the source of the highest moral feelings. This was not an exclusively English philosophy—Rousseau in France had been one of the first to preach the virtues of nature and the simple life—but it was in England with its flexible religious tradition that the feeling for nature was accepted in the canon of orthodox faith.

The belief in nature as a source of spiritual truth depended ultimately on the belief that the universe was literally the handiwork of God and that the forms within it were an extension of the divine essence. Through nature and the imagination man could thus experience both the material and the spiritual world, could find in the forms of nature a mirror of his own duality. Behind the philosophy of Romanticism lay the assumption that man, though part of nature, was also spiritually superior and that the physical world around him had been placed there by a beneficent Creator.

Soon after Constable's death the philosophic climate of Europe changed. Doubts about man's unique place in the universe began to creep in and with them doubts about the origin and function of nature. Far from being a godlike creation, man was seen now to be no more than a creature like the rest. Truth to nature ceased to have its old meaning because nature no longer possessed the mystical significance formerly ascribed to her. The invention of the camera, too, shattered the whole basis of Romantic art. Here, it seemed, was truth to nature in an incontrovertible form, and when it was seen that, in the past, feeling and imagination had invariably falsified the artist's vision, the inference was that feeling and imagination were things to be eschewed and it was the artist's duty to paint the physical world as objectively as possible. The Pre-Raphaelites with their meticulous concern for detail were not so much following the practice of the early masters as paying an unconscious tribute to the new standards of truth imposed by the camera. Even Ruskin, for all his Romanticism, accepted those standards and deluded himself that Turner's art was based on a close copying of nature.

Truth to nature in the poetic sense that Constable conceived it was thus suddenly outmoded. With the camera as their rival, artists tried unashamedly to beat the camera at its own game by using every technical trick to produce the smooth, detailed finish of a photograph. Compared with a photograph of a tree or field, how hopelessly 'out' the same thing painted by Constable must have seemed. The camera's recording of the visual world was automatically accepted as the true one, and the qualities of poetry and imagination which had been the distinctive feature of Romantic art were regarded now as mere interpolations. If one wanted truth to nature one could get it on the camera plate and with a wealth of concomitant detail into the bargain. Indeed it was the camera's capacity for recording an infinite amount of detail that was indirectly responsible for much of the finicking quality of Victorian painting. To compete with their new rival, painters spent a great deal of time and energy in such technical feats as imitating the veins in marble or the surface qualities of silks and velvets. The only advantage

the artist seemed to enjoy over the camera was his command of colour, and in a desperate effort to make the most of it painters vied with one another in choosing subjects in which the colour possibilities could be exploited in the crudest way.

In this garish welter it is hardly surprising that the kind of art that Constable stood for failed to hold its own. Constable himself always hoped that his art would be popular in his own lifetime, but he was sufficient of a realist to see that the odds were against him. The seemingly plausible argument put forward by Lawrence and others that subject made the picture was to prove fatal to Constable's influence in England immediately after his death, and was instrumental in loading the Academy walls with inferior art for the next seventy years. It was ironical that Constable, the most English of painters, should have had more recognition in France than he did in his own country. Success in Paris was for him small consolation for the stubborn neglect of his countrymen. Yet if luck had been a little on his side things might have been very different. Had a steady flow of his pictures reached France over a number of years it is probable that his success there would have forced the English public to revise its opinion of his art. Archdeacon Fisher had the possibility in mind when he wrote: 'The stupid English public which has no judgement of its own, will begin to think there is something in you if the French make your works national property. You have long lain under a mistake. Men do not purchase pictures because they admire them, but because others covet them.'

As it was, the financial difficulties of certain French picture dealers halted the flow of Constable's paintings into France, with the result that the reputation he had established there had no chance of making the sort of cumulative growth that might ultimately have influenced opinion across the Channel. But while the English public remained generally indifferent to Constable's art, the stir it had created in Paris had repercussions there. Sufficient of his paintings had been seen to make the lesson of his art abundantly clear. In fact so well did the French learn that lesson that his example became for them a liberating influence. As a pioneer he was honoured by such men as Delacroix and Géricault, and the succeeding generation, either directly or indirectly, were indebted to him for a new conception of naturalism. In England, on the other hand, the lesson of Constable's art was only imperfectly grasped by other painters. There were of course a number of imitators, men who copied certain elements of his style, but there were few followers in the genuinely creative sense. No one in fact had genius enough to make Constable's discoveries the basis of a new and equally personal art. In France the younger generation of artists were sufficiently original to avoid the inhibiting effects of mere imitation, and the freedom of technique that had once startled Paris in Constable's picture 'The Hay Wain' was developed by them in new and bolder ways.

To what extent Constable actually influenced the French Impressionist painters remains a vexed question. On the French side there is a tendency to play this influence down and to assert that any similarity of style is merely the reflexion of a general trend in European art which both Constable and the Impressionists shared. To take this view seems to me a perverse misreading of the facts, a curious example of the French reluctance to admit that their art owes anything to foreign influences. Actually, as time goes on, the influence of Constable and Turner on such men as Monet and Pissarro tends to become clearer and more convincingly documented. And the Impressionists themselves, in

49

D

admitting their debt to Corot and Delacroix, were in effect admitting their debt to Constable whose art (together with that of Bonington) had first opened the eyes of Corot and Delacroix to the possibilities of naturalism.

But though the Impressionists certainly owed a debt to Constable, that debt was necessarily a limited one because, as I have tried to show, the philosophy of the age had changed men's attitude to nature, so that the Impressionists' vision of the world differed essentially from that of Constable. By accepting a more materialistic view of nature they created standards of naturalism which were a great deal more flexible than those of Constable's day. The point is, of course, that a feeling for nature was no longer identified with the religious experience as it had been for the Romantics. The Impressionists were thus free to create their own standards of naturalism, to see nature in a purely personal way without reference to religious or philosophic truths. It is this divorce of art from ethics which makes the Impressionists the first of the Moderns.

The difference, then, between Constable and the Impressionists is the difference between the old world and the new, between the mystical view of nature and the mechanist one. What the generation of Monet and Pissarro learned from Constable was his technique rather than his way of seeing things. To them the world was a very pleasant place and they were content to express their delight in it by the use of strong and vibrant colour. Truth to nature as Constable conceived it, the dual standard of visual and moral truth which assumed the existence of a spiritual reality behind material forms, seemed irrelevant to a generation of painters who tended more and more to base their artistic creed on the fashionable doctrine: art for art's sake. For Constable the painting of landscape implied also a sense of communication with nature herself through the medium of sentiment and feeling. The painter who relied too much on intellect or had had his spontaneity blunted in schools or academies was bound to overlook those simple effects of nature which yielded so often the profoundest and most rewarding truths.

Such an attitude was unlikely to find adherents among the painters of a more scientific age. Yet there was, surely, one exception who, though not a Frenchman, is included in that group of nineteenth-century painters whom we loosely call the Impressionists. It is perhaps the uncompromising nature of his technique and the apparent modernness of his palette that makes us fail to recognize how fundamentally close he is to Constable. He himself called Constable 'splendid', and he had seen the examples of Constable's work exhibited at the South Kensington Museum and the National Gallery, London. The sketch for 'The Valley Farm' and the large picture, 'The Cornfield', made a lasting impression on his mind. The following extracts from his letters on the subject of senti- ment and feeling might almost have been written by Constable himself:

'It is the painter's duty to be entirely absorbed by nature and to use all his intelligence to express sentiment in his work so that it becomes intelligible to other people.'

'The true painters are guided by that conscience which is called sentiment, their soul.'

And on the question of spontaneity, of learning to paint by direct contact with nature rather than by the precepts of schools and academies, the resemblance to Constable's views is equally striking:

'In a certain way I am glad that I have not *learned* painting, because then I might have *learned* to pass by such effects as this. Now I say No, this is just what I want—if it is impossible, it is impossible; I will try it, though I do not know how it ought to be done. *I do not know myself* how I paint it. I sit down with a white board before the spot that strikes me, and I look at what is before my eyes, I say to myself, that board must become something; I come back dissatisfied—I put it away, and when I have rested a little, I go and look at it with a kind of fear. Then I am still dissatisfied, because I still have that splendid scene too clearly in my mind to be satisfied with what I made of it. But I find in my work an echo of what struck me, after all. I see that nature has told me something, has spoken to me, and that I have put it down in shorthand. In my shorthand there may be words that cannot be deciphered, there may be mistakes or gaps; but there is something of what wood or beach or figure has told me in it, and it is not the tame or conventional language derived from a studied manner or a system rather than from nature herself.'[1]

The writer of these letters was Van Gogh.

At first sight Van Gogh and Constable may seem very different painters, and in some respects they are. What they have in common are certain fundamental beliefs and attitudes which the difference in their style and period tends to make us overlook. In spite of the lapse of time which now separates us from Van Gogh, he remains essentially a modern painter and his genius is of the kind that creates its own standards of judgment and enlarges the whole concept of art. And in his short, tortured life he plumbed depths of the human psyche which Constable in his more stable and traditional world never touched.[2] These things are implicit in the force and character of Van Gogh's art. Yet for all his modernity he was a traditionalist in his approach and, like the English Romantics, his view of nature was based on a sense of a spiritual reality behind material forms. What he shared with Constable was a philosophy, a belief that the artist could extract from the physical world around him an element of moral truth.

It is worth remembering that both Constable and Van Gogh had first intended to enter the Church but had jibbed at the intellectual drudgery of a clerical training. The fact is significant. Neither of them was an intellectual in the sense that they believed in the intellect as the supreme instrument of truth, and when they turned to art, it was through feeling and the emotional response to nature that their artistic vision was evolved. When Van Gogh paints a single bough of fruit blossom, or Constable a study of a cloud, it summarizes a whole mode of perception, that quality of Romantic insight that gives 'completeness' to the part through a sense of immanent unity. What is really important in English Romanticism is not the grandiose fantasies of Martin and Turner,

[1] Compare this with an extract from a letter written by Constable in 1802. 'For the last two years I have been running after pictures, and seeking the truth at second hand. I have not endeavoured to represent nature with the same elevation of mind with which I set out, but have rather tried to make my performance look like the world of other men I shall return to Bergholt, where I shall endeavour to get a pure and unaffected manner of representing the scenes that may employ me.'

[2] The extent of this difference may be gauged by a comparison of Constable's sunny 'Cornfield' with the picture by Van Gogh, 'Cornfield with Crows', painted just before his death. Of another cornfield picture painted at this time Van Gogh writes: 'The subject is a great expanse of cornland under overcast skies and I did not need to go out of my way to express its melancholy and utter loneliness.'

51

but the philosophy that produced art of an entirely opposite sort, the art that saw nature in depth, so to speak, and extracted from her simple and apparently commonplace forms something of profound significance. It was this philosophy that inspired the best of Wordsworth's poetry as well as the naturalistic painting of Constable, and it gave European art for a brief moment in time an affinity with the great landscape art of ancient China.

Whether or not Constable had any stylistic influence on Van Gogh it is hard to say. Certainly some of Van Gogh's early work, and particularly his feeling for landscape and peasants, has a great deal in common with Constable, though it may be argued that the influence here came from the Romantic school of France rather than from England. The point is of course that the French Romantics were largely an offshoot of their English counterparts, and it was principally through Bonington and Constable that the artistic link between the two countries was established. What such painters as Corot, Millet, Théodore Rousseau and Daubigny got from Constable was not only an element of style but also his philosophy, his belief in nature as a moral influence. The Impressionists on the other hand by-passed his philosophy and made their own innovations by emulating his technique and his disregard of formal rules. The French Romantic painters, being nearer to Constable in time and having been to some extent prepared for him by the nature theories of Jean-Jacques Rousseau, followed him more closely, but without ever quite achieving his freshness and spontaneity of touch.

Of this group of painters only Corot in his early work, really, displays the same sort of poetic feeling as Constable, the same capacity for seeing nature from the inside. Though Daubigny in his management of greens and his atmospheric skies sometimes gets a Constable effect, it is an effect produced by a sensitive imitation of the Romantic style rather than by any qualities of imaginative vision. Corot on the other hand, in his attitude to nature, is genuinely of *le parti romantique*. In his early paintings the imaginative quality is paramount and one has in these landscapes the feeling that the effects of light and shade are for him as deeply emotive as they are for Constable; that even when he is most a Classicist, at the period when he first painted in Rome, his real concern is not so much with classical form as with the romantic appeal of light and atmosphere, with trees and rocks, and the blue distances of the Roman Campagna. The affinity with Constable is here so close that it is hard to resist the conclusion that Corot would not have felt about nature in quite this way had not Constable's 'Hay Wain' been exhibited at the Paris Salon in 1824.

By these comparisons I have tried to show that Constable's reputation in France was greater and more lasting than it is now fashionable to suppose. Constable himself, who did not like the French and had no particular wish to shine amongst them, was not idly boasting when he said of his Paris exhibits: 'My landscapes have made an epoch there.'

It is probably true to say that every original artist makes it impossible for anyone else to paint significantly in quite that way again; indeed the more original and personal his art, the more inadequate does the work of his imitators appear. Constable himself avoided imitation and advised others to do the same. Unfortunately those who followed him in England were less wise and in attempting a direct copy of his style they either travestied it or produced at best a tame and conventionalized pastiche. With the excep-

tion of David Cox, the water-colourist, who took to oil painting late in life and occasionally caught something of Constable's sparkle in that medium, the record of English landscape art in the years immediately after Constable's death is sad indeed. I do not include Turner here because he and his influence are a subject in themselves. Turner is outside the scope of this study. But in passing it is worth noting that Turner was more fortunate

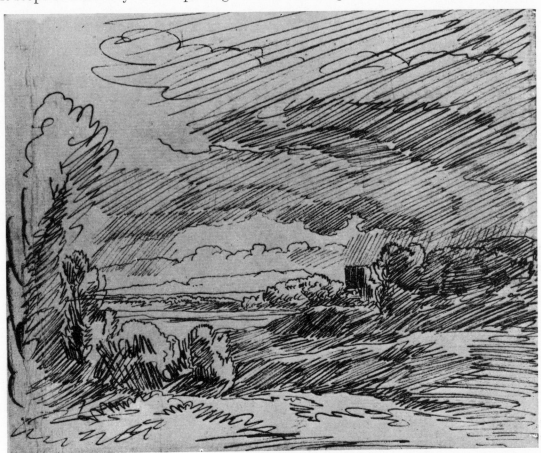

(ix) *View of Castle Hedingham, Essex. Pen and Indian ink. About* 1802

in his posthumous reputation than Constable was. Though he died a lonely and neglected genius, producing at the end of his life those essays in pure light which the public dismissed as proofs of a failing mind, the legend he had created lived on and no Victorian artist could paint a sunset or an evanescent effect of light without borrowing something from him.

In contrast Constable was remembered by no section of the public and by only a small circle of friends. It may be that the very Englishness of his art proved fatal to his reputation. People found it hard to believe that anything so radically English as Constable's landscapes could really be great and significant art. Over the years Italy and the old masters had created in the public mind a fixed notion of what painting should be,

and anything that did not conform to the accepted canon was judged to be of little worth. Turner, with his more exotic colouring and his frequent choice of classical subjects, provided just that element of 'foreignness' which reassured the public. But perhaps more than anything else it was the nature of Constable's style which accounted for his unpopularity. In art the English have an instinctive taste for the smooth, closely-worked surface in preference to the broad, imaginative touch, and Constable's lack of 'finish', so often objected to in his own day, must have been doubly unpalatable to a later generation which had begun to base its judgments of art on the realistic standards of the camera. What chance had the painter of 'Hadleigh Castle' and 'The Leaping Horse' of being remembered when there were so many up and coming men who could delight the Academy public by imitating the bloom on grapes, the sheen of satin or the surface quality of marble with all the accuracy and smoothness of a photograph? Constable's use of the palette-knife was something the public could not endure, just as the English public of a future generation was to take exception to the rough 'unfinished' quality of Sickert's pictures.

After Constable's death in 1837 he and his work were virtually forgotten until 1888 when the artist's daughter bequeathed a large number of her father's paintings and drawings to the nation. This rediscovery of Constable marked a turning-point in British painting. What sharpened the impact of his art was the realization that it anticipated much of what had been done in France by the Impressionists, and that in Constable's day English art, far from being provincial and derivative, was in fact the focal point of the European tradition. Thus Constable, who had first been recognized in France, returned to his native country with his achievement heightened by the glow of French prestige. This new view of his art had the effect of re-establishing the relationship between French and English painting, of inspiring English painters to break free from the stale conventions of the 'subject' picture which had ruled the Academy world for the last fifty years. From this Anglo-French *entente* sprang the early work of Wilson Steer, that series of enchanting beach scenes painted in the late Victorian and Edwardian periods, in which a French warmth of colour is combined with a poetic feeling for light and atmosphere which is wholly English.

In our own day the legacy of Constable may seem to have less relevance than it had fifty years ago, for in this century the painter's attitude to nature tends to be more rational and analytic, though there are still artists for whom landscape as such can inspire a profundity of vision. In style perhaps such artists may seem to have little affinity with Constable, but the quality of their response, the inner vibration of feeling, so to speak, will be fundamentally akin. In modern English painting the work of Ivon Hitchens, for instance, expresses in contemporary idiom the same romantic feeling for landscape, the same capacity for seeing nature in significant depth, that was the essence of Constable's art.

Being ourselves part of nature, we cannot indefinitely reduce our art to the abstract world of mathematics without running the risk of ultimately killing it off through a process of etiolation. Sooner or later we shall have to look again at the world around us, attuning ourselves to its forgotten rhythms and nuances. What we see then will not be nature as Constable saw her; but the vision she yields to some future generation of

54

painters may be none the less valid and rewarding. Constable himself was a realist and saw that painting in a scientific age must be a thing of the mind as well as of the sense. What he says on the subject has a curiously modern ring and disposes of any notion that he was nothing more than a woolly mystic or a sentimental nature-worshipper.

'In such an age as this', he writes (he means of course the early nineteenth century), 'painting should be *understood*, not looked on with blind wonder, not considered only as a poetic aspiration, but as a pursuit, *legitimate, scientific* and *mechanical.*'[1]

Could modern art have a more enlightened advocate?

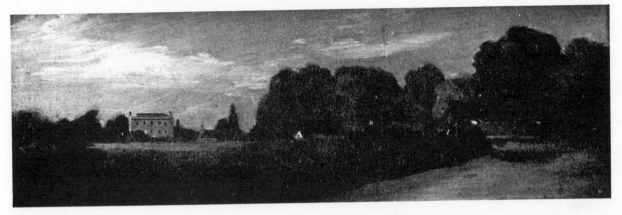

(x) *House in which Constable was born*

<hr/>

[1] Compare this with the views expressed by Samuel Palmer: 'But the real charm of art seems to me not to consist in what can be best clothed in words, or made a matter of research or discovery. Its technical means are conversant with several branches of science; and it demands lifelong investigation of phenomena; but I do not think that the *result* is a science, though Constable very truly said that every picture was a scientific experiment. The result I take to be not interpretation, but representation—its first appeal not to the judgement but the imagination.'

(Palmer, in a letter to L. R. Valpy, 1875.)

Constable and the Sea

I was always delighted with the melancholy grandeur
of a sea shore

CONSTABLE, in a letter to Maria Bicknell, 1814

IT is probably because Constable's name has been so inseparably associated with the kind of subjects he most frequently chose to paint, mill-streams, rainbows, farmhouses, navigable rivers, that his paintings of the sea and his shipping studies have never received the special attention they deserve. For this neglect the artist himself may be partly to blame. In a letter to Fisher, written in 1824, Constable says: 'The sketchbook I am busy with a few days when I will send it [*sic*]—they are all boats—and coast scenes—*subjects* of this kind seem to me more fit for execution than sentiment. I hold the genuine—pastoral—feel of landscape to be very rare and difficult of attainment—and by far the most lovely department of painting as well as of poetry.'

The word 'sentiment' here is a key word and covers that complex balance of poetic perception and emotional association which makes Constable's landscape painting the personal thing it is. And if sometimes this painting betrays signs of weakness, as for instance in the larger versions of 'The Glebe Farm', it is because Constable has allowed an over-charge of emotional association to destroy this disciplined balance, so that he no longer responds directly to his subject but projects his feelings into it and in consequence edges what he calls 'sentiment' dangerously near the borderline of sentimentality.

In his paintings of the sea this danger does not exist. Indeed, it is arguable that here more than anywhere else he is in the purest sense a painter. Free from extraneous influences, he can paint the subject exactly as he sees it, can record here, as he does in his sky studies, some momentary effect of atmosphere and light without any reference to previous modes of feeling. It is this quality of purity and directness which makes the National Gallery sketch of 'Weymouth Bay' one of the great documents of nineteenth -century naturalistic painting, a major work by any standard of comparison. And in his splendid Brighton series, where he anticipates the kind of thing that Boudin did by over a quarter of a century, he achieves in nearly every sketch the same pristine quality.

If in the letter to Fisher already quoted Constable seems to deprecate the sea as a subject for painting, the explanation is probably his dislike for the kind of sea picture so much in vogue in his own day, the sentimentalized beach scenes turned out by such artists as Callcott and Collins. In comparison with these Constable's superiority is at

once apparent; and if one extends the comparison to include all the painters of the English School, who was there after all, with the possible exception of Bonington, who painted the sea better than Constable? The other name that comes to mind is that of Turner; but Turner, brilliant though he was in suggesting the movement of large masses of water, often lost the subtleties of wave-form by his habit of over-dramatizing. Ruskin complains that Turner all his life 'painted the sea too grey and too opaque, in consequence of his early study of Vandervelde' and that ' he never seemed to perceive colour so truly in the sea as he saw it elsewhere'.

What Constable and Turner had in common was an instinctive feeling for ships, an ability to give them life. And in his drawings especially, Constable shows a trained eye for nautical detail. (Note the way he draws a pulley and suggests the strain or slackness in a rope.) Among the masterpieces of nineteenth-century painting is his sketch of 'Brighton Beach with Colliers', now in the Victoria & Albert Museum. It is one of those paintings which by their freshness and vitality acquire the timelessness of great art. The rich blues of sky and sea take on an added brilliance by contrast with the black coal ships lying off shore, and the beach glows with all the warmth of strong sunlight beating down on sand. Here again Constable shows himself a master of natural effect; in this sketch every graduation of tone is the result of careful observation and nothing is put in or left out for the sake of conventional 'picture-making'.

It is no accident that his sea sketches are on the whole even more atmospheric than his landscapes. He is again merely recording the evidence of his eyes, for in the neighbourhood of the sea the reflection of light is greater and the rendering of it in paint necessitates the keying-up of the artist's palette. Constable's habit of keeping his eye on the object accounts for the distinctive quality of his sea painting. Unlike so many of his contemporaries, he never used the sea as a vehicle of drama. The sinking barque overwhelmed by mountainous waves, a subject beloved in all its variations by the art world of his day, never had for him the slightest appeal. By his standards there was drama enough in the sunlit figures on the beach and in the changing tones of sea and sky.

Far from being a minor branch of his art, Constable's sea pictures are in many ways the freest and most impressionistic things he ever did. In its ever-changing form and colour the sea presented the supreme challenge, demanding from the painter the greatest technical skill: in comparison with its evanescent effects the painting of landscape was an almost simple matter. It may even be said that from his first patient study of the sea Constable attained his wonderful mastery of light. We know that at an early date the marine artist W. Van de Velde exerted a strong influence on Constable (as he did on Turner), and in some of his first shipping drawings Constable's homage to the Dutchman leads him into making exact copies of seventeenth-century types of vessels. From Van de Velde Constable learned to paint luminous and sketchy skies; he learned also how to give poise and movement to a ship, knowledge which he afterwards reinforced by careful studies of his own.

His first prolonged contact with the sea was the trip he made from London to Deal by ship in 1803. 'I was near a month on board,' he writes to his friend Dunthorne, 'and was much employed in making drawings of ships in all situations. I saw all sorts of weather. Some the most delightful, and some the most melancholy. But such is the

57

enviable state of a painter that he finds delight in every dress nature can possibly assume.'

One result of this voyage was a strengthening of Constable's draughtsmanship. The studies he made are mostly in pen or pencil with washes occasionally added, in the eighteenth-century manner. But his month aboard was important in another way: it taught him to look at the sea with something more than a landsman's eye. Turner is reported to have spoken contemptuously of Constable's knowledge of ships, supposing no doubt that Constable was purely a countryman who had no first-hand experience of the sea. Actually, the world of sea and ships was something Constable must have known since boyhood. From the tower of Dedham church he could see on a clear day the shipping in the sea-roads at Harwich, and there were times when the sea was literally on his doorstep. During the spring tides when the sea builds up in the Stour estuary it overtops the weir known as Judas Gap and floods the river channel with salt water as far as Flatford Mill. Below Flatford, near the head of the estuary, lie Manningtree and Mistley, thriving river ports in Constable's day, where brig and brigantine used to unload their cargoes on the busy quays. At Mistley there was a shipbuilding yard that flourished till about 1800. As a young man Constable must have known it when it possessed all the charm described by Arthur Young, the agriculturist: 'The little dockyard with ships building in the very bosom of a hanging wood—a lively beautiful scene of singular pleasing features.' Ships, as well as mills, locks and cornfields, were an integral part of Constable's boyhood world and his instinctive feeling for them comes out again and again in the paintings and drawings of coast and river subjects which he made throughout his life. At Harwich the River Stour forms a common estuary with that of the Orwell and on this sister river Constable found an additional source of material for his sketches. The small study of 'Shipping on the Orwell,' now in the Victoria & Albert Museum, is one of the boldest and most characteristic things he ever did, and if one accepts the Museum's dating of it, circa 1806–9, one of the most astonishing documents of early Impressionism.[1]

The shore at Harwich provided Constable with the subject for what Fisher describes as 'the sea-coast windmill', or, to name it correctly, 'Harwich Lighthouse'. Two versions of this painting exist and it is in reference to one of these that Constable writes to Fisher in 1823: 'I have not a sea-piece—or "Windmill Coast Scene" at all. I gave it to Gooch[2] for his kind attention to my children. Half an hour ago I received a letter from Woodburne[3] to purchase it or one of my sea-pieces—but I am without one—they are much liked. . . .'

The popularity of Constable's sea-pieces was probably one of the reasons why Fisher, always eager to promote his friend's interest, dropped a discreet but practical hint to encourage Constable to paint them. 'On my taking leave of Osmington', he writes, 'I thought of you, and brought away an old lobster pot and an assortment of our shore productions. These I have put into a box and sent you this day by the Old Salisbury,

[1] Personally I should date it later. The style of the figures and the general feeling of the paint make me think it was done about 1817. But even so, it is a wonderful anticipation of the kind of style which the French are generally given the credit for inventing.
[2] Dr Robert Gooch.
[3] A picture dealer.

which rendezvouses at the Bell & Crown, Holborn. I hope to see them some day in the foreground of one of your sea-pieces.'

And later Fisher wrote to Constable to ask him to send down to Salisbury one of his coast 'Windmills'—the Harwich Lighthouse pictures—no doubt because it seemed to him the kind of painting that was most likely to win converts to Constable's art. Unfortunately, as we have seen, Constable had to reply that he had 'not a sea-piece—or "Windmill Coast Scene" at all'. For once in the history of Constable's art demand exceeded supply.

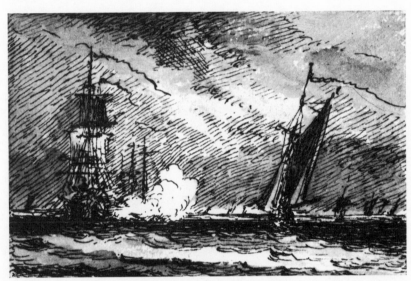

(xi) *Yacht race, with man-of-war firing a signal. Pen and ink*

But it wasn't only in Constable's immediate circle that the distinctive quality of his sea-pieces and his shipping studies was recognized. In 1824, when Constable's art was the talk of Paris and the French dealer Arrowsmith was over in London negotiating with him for a supply of pictures for the French market, he writes to Fisher who has asked for the loan of some sketch-books:

'Everything which belongs to me, belongs to you, and I should not have hesitated a moment about sending you my Brighton book—but I will tell you—just at the moment you wrote to me my Frenchman was in London. We were settling about work and he has engaged me to make twelve drawings (to be engraved here, and published in Paris), all from this book, size of the plates the same as the drawing, about 10 or 12 inches. I work at these in the evening. This book is larger than my others—and does not contain odds and ends (I wish it did), but all complete compositions—all of boats, or beach scenes—and there may be about 30 of them.'

As far as is known, nothing came of the project and the French public never saw the engravings of these Brighton studies which are in their way as characteristically English

59

as 'The Hay Wain' or 'A View on the Stour'. That Arrowsmith should have chosen them is, I think, both a tribute to his artistic judgment and to the masterly quality of the drawings themselves. For Brighton has a special place in Constable's art and the paintings he did there—particularly his oil studies of the beach—seem to me to possess a brilliance and spontaneity that he seldom achieved so consistently elsewhere. Yet curiously enough he disliked the place itself which had for him the raw and (to use his own phrase) 'unfledged' quality that we are apt to associate with the New Towns of our own time. His comments on Brighton make interesting reading to a generation that is inclined to look back on the Brighton of those days as a kind of Regency paradise. This is the description of the place he sends to Fisher when he visits it in August 1824:

'Brighton is the receptacle of the fashion and offscouring of London. The magnificence of the sea, and its (to use your own beautiful expression) everlasting voice, is drowned in the din and lost in the tumult of stage coaches—gigs—"flys" etc.—and the beach is only Piccadilly (that part of it where we dined) by the sea-side. Ladies dressed and *undressed*—gentlemen in morning gowns and slippers on, or without

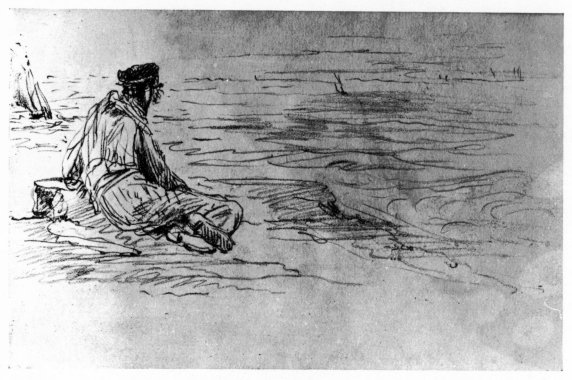

(xii) *Man by the sea*

them altogether about *knee deep* in the breakers—footmen—children—nursery -maids, dogs, boys, fishermen—*preventive service men* (with hangers and pistols), rotten fish and those hideous amphibious animals the old bathing women, whose language both in oaths and voice resembles men—all are mixed up together in

endless and indecent confusion. The genteeler part, the marine parade, is still more unnatural—with its trimmed and neat appearance and the dandy jetty or chain pier, with its long and elegant strides into the sea a full quarter of a mile. In short there is nothing here for a painter but the breakers—and sky—which have been lovely indeed and always varying. . . .'

The scene which would have delighted Rowlandson had no appeal for the more fastidious Constable. And even the countryside round Brighton displeased him. 'The neighbourhood of Brighton', he notes on the back of an oil sketch, 'consists of London cowfields—and hideous masses of unfledged earth called the country.'

If Georgian London had been a healthier place Constable would probably never have set foot in Brighton and a wonderful series of paintings and drawings would never have materialized. In a letter written to Constable in November 1824, Fisher quotes the famous surgeon John Abernethy as saying: 'There is not a healthy man in London, such is the state of the atmosphere and the mode of life'. As an antidote to the unhealthiness of London, the sea air of Brighton was then the fashionable choice, and Constable wisely sent his wife and children there for long spells in the summer and autumn, he himself joining them when work permitted. Sometimes he took pictures down with him to be completed, thus avoiding any loss of time. 'I am looking for a month's quiet here,' he writes to Fisher from Brighton in July 1824, 'and I have brought with me several works to complete.'

Constable made two visits to Brighton in 1824 and was there again in the four subsequent years and in 1830. Though he disliked its fashionable world, there were always the sea and beach as compensation, and in his studies of them—those exquisite little sketches painted in the open air with his painting-box propped on his knee and the paper or millboard resting in the lid—one can almost hear the swirl and tumble of the waves. Indeed, in nearly all his Brighton sketches there is a carefree quality which suggests that the atmosphere of the place and the happiness of his children there brought Constable a degree of relaxation he was seldom to enjoy again; and if now and then the puritan side of his character voiced its prejudice, the artist in him responded wholeheartedly to the animation of the Brighton scene. As he sketched on the beach there were always gaily dressed strollers to supply an appropriate note of colour, and his delight in spontaneously recording every effect he saw comes out in the racy painting of these figures, their life and movement often brilliantly suggested by no more than a flick of pigment from the brush. Richard Jefferies, the nature writer, says that Brighton has a quality of light found nowhere else in England and that in sharpness and clarity it resembles even the vivid light of Spain. If one is tempted sometimes to speculate on the kind of art Constable might have produced had he gone abroad and painted under a more powerful sun, one may find the answer in part, perhaps, in some of the sparkling sketches made on Brighton beach.

In his large painting 'The Marine Parade and Chain Pier, Brighton', Constable has used a variety of Brighton *motifs* and combined them in a full-scale composition, a composition built up, one might say, on the contrasting interrelation of the old, traditional Brighton with what was then the fashionably new. The fashionable element is represented here by the modishly dressed women at the tide edge, by the Chain Pier

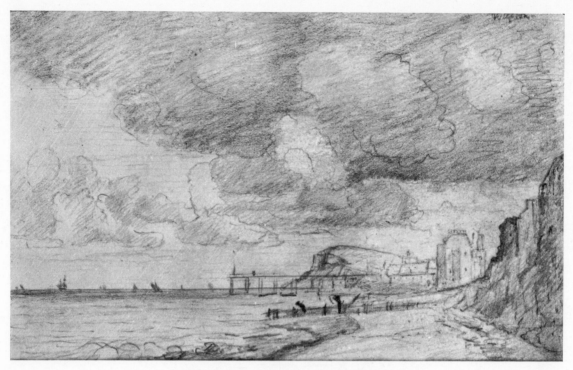

(xiii) *Walton-on-Naze, Essex. Pencil*

('the dandy jetty', to use Constable's phrase) and the Marine Parade stretching along the shore, backed by a terrace of elegant new houses whose stucco fronts rise like a cliff-face on the skyline. And combined and contrasted with this newly-created genteel Brighton is the older, rougher one that fashion has not touched, the tarry, seafaring Brighton of the earlier days, where fishermen busy themselves among the boats and gear that strew the beach, and the coastguard standing at the water's edge keeps a watchful eye on some vessel out at sea.

In the process of painting this picture Constable altered its composition by lengthening the pier and painting out a large sail in the vicinity of the pier-head. Traces of these changes can still be seen under the surface of the present paint. As in most of his large studio pictures, a more academic response has here replaced the brilliant immediacy of the sketches, and in his effort to provide the kind of detailed realism the contemporary public looked for, he has tended to make parts of his foreground a trifle stiff and stagy. All the same, this great view of Brighton has a quality of atmosphere which the studio air of Charlotte Street has not been able to stifle, and in his painting of the sea Constable has achieved a buoyancy and movement which not only create an image of the sea itself, but seem even to add what Fisher calls 'its everlasting voice'.

After his Brighton visits Constable seems to have made fewer oil studies of the sea and his last important series of coast subjects are in water-colour. In 1833 his son John, who was at school at Folkestone, injured himself while sleep-walking, and Constable went down there for a fortnight in October to be with him. During this time he filled a

number of sketch-book pages with water-colour drawings of shore and harbour scenes, drawings which exemplify magnificently the power and assurance of his later style. It is unfortunate that these sketch-book pages have been dispersed and that the public has little chance of seeing them together, as it has the Brighton series now in the Victoria & Albert Museum. What they show superlatively well is the final mastery Constable achieved in the medium of water-colour. Effects of shifting light and tone are wonderfully suggested by a method of broken washes, as though the drawing were a kind of water-colour mosaic, built up by piecing together a number of rough-edged colour surfaces. And in his later pencil drawings he imparts a comparable suggestion of light and move-ment by a curiously free, almost straggling, line which seems sometimes to float over the surface of the paper like a blown thread. Yet behind it all there is always a sense of absolute control and that quality of individuality which is manifest in every touch. One may call it style or manner for want of a better word, but essentially it is neither, and all his life Constable made clear his rejection of the sort of conscious artifice these words imply. Rather, what we have in these Folkestone drawings is the kind of art that creates its own intrinsic form through the depth and validity of the artist's personal response; and it seems appropriate that the sea, which has always been so inseparably bound up with our native genius, should have inspired in Constable such truly English art.

THE PLATES

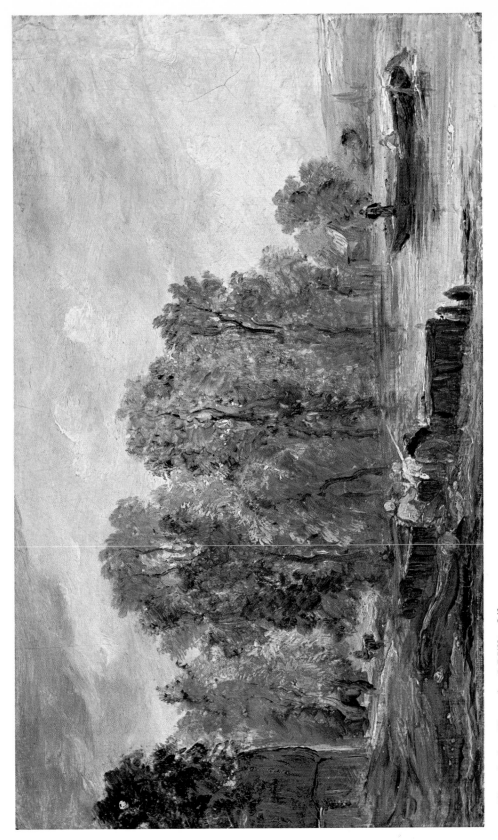

1 Sketch for 'Stratford Mill'. Oil

2 Landscape near an estuary. Oil

3 Study of flowers. Oil

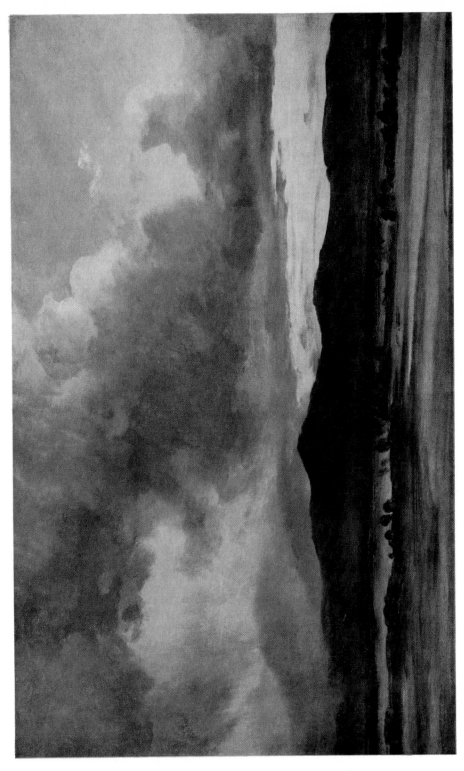

4 View in the Lake District. Oil

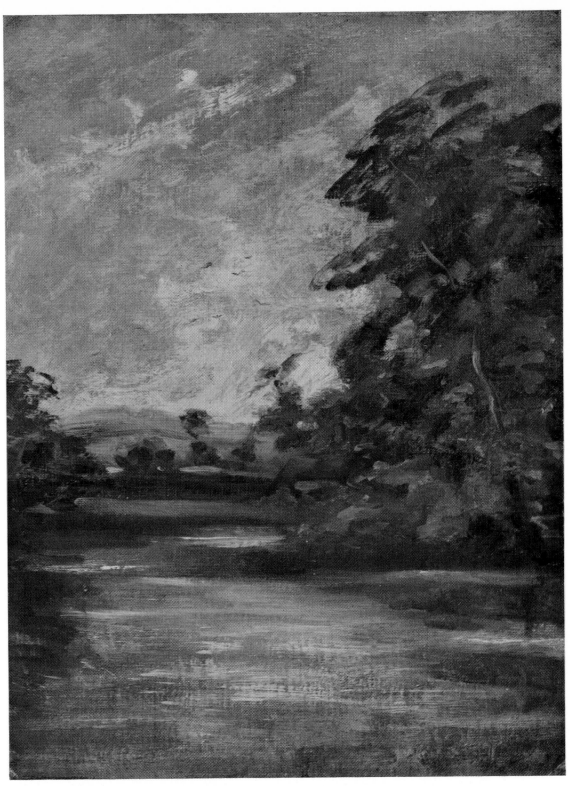

5 View on the Stour with cottage. Oil

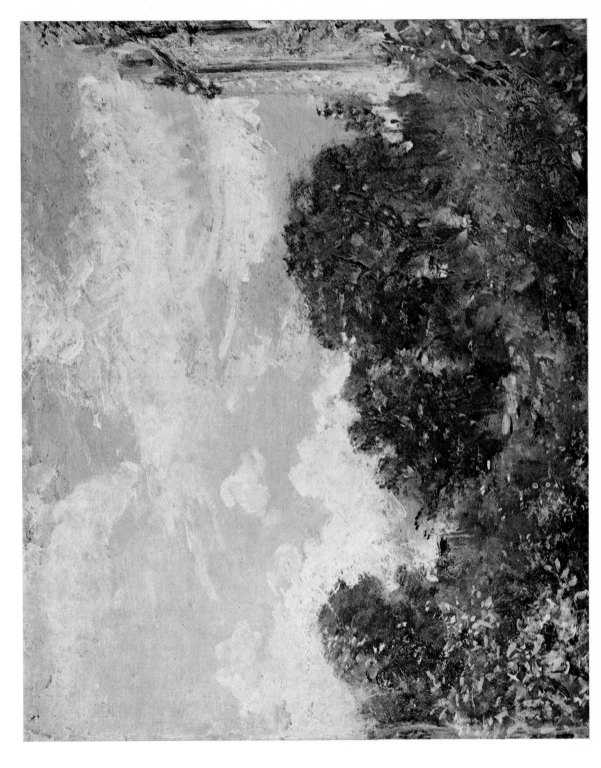

6 Study of sky and trees, with a red house. Water-colour

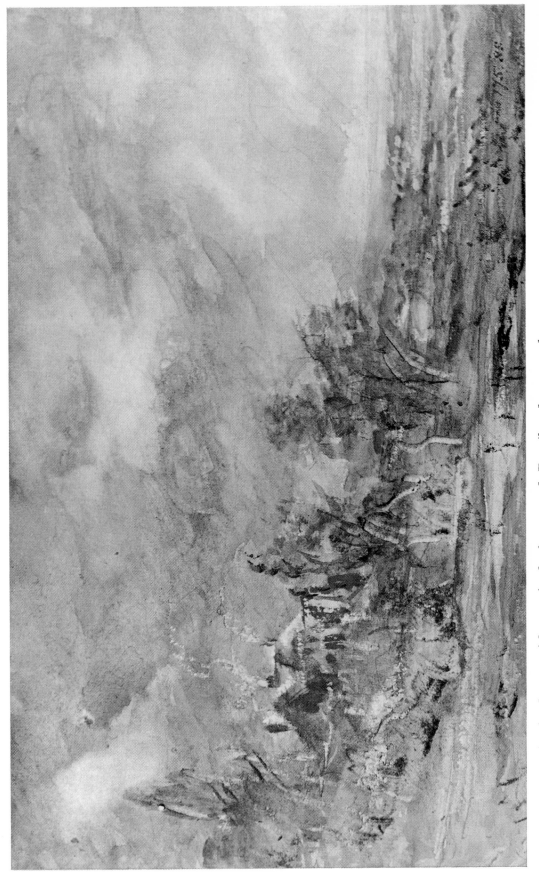

7 View over a wide landscape with trees in the foreground. Pencil and water-colour

8 Waterloo Bridge from Whitehall Stairs. Oil

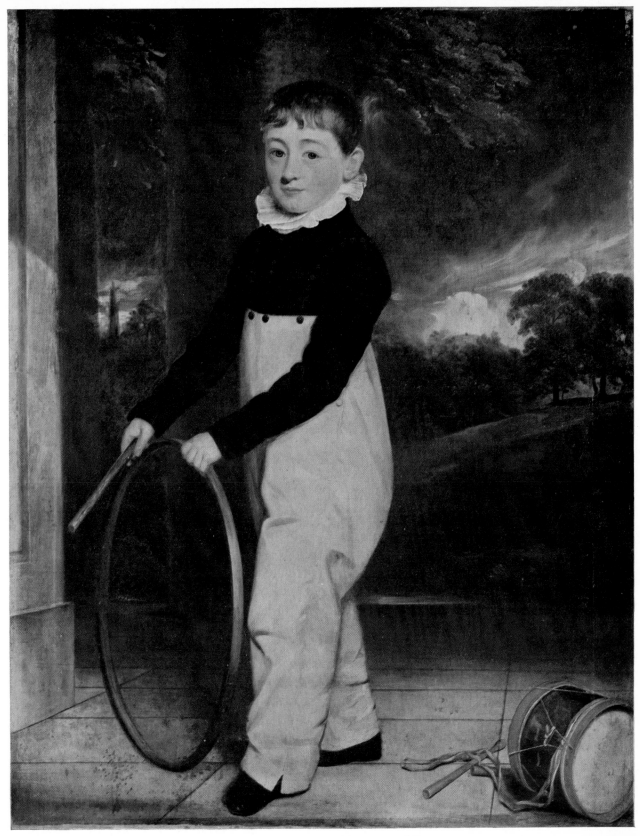

9 Portrait of John Charles Constable, the artist's eldest son. Oil

10 Hampstead Heath with passing shower. Oil

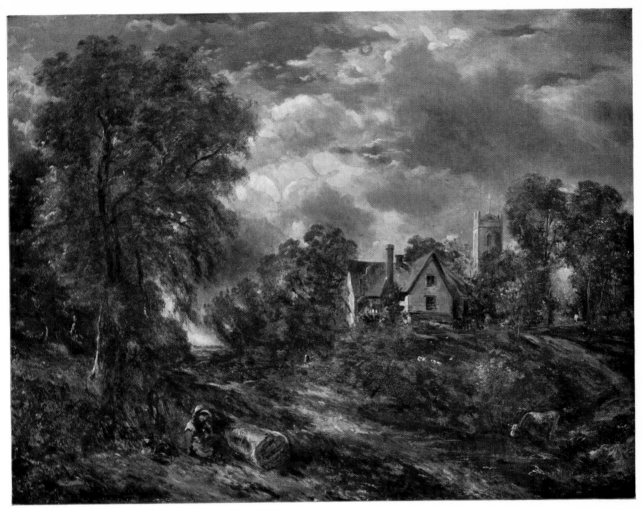

11 Study for 'The Glebe Farm'. Oil

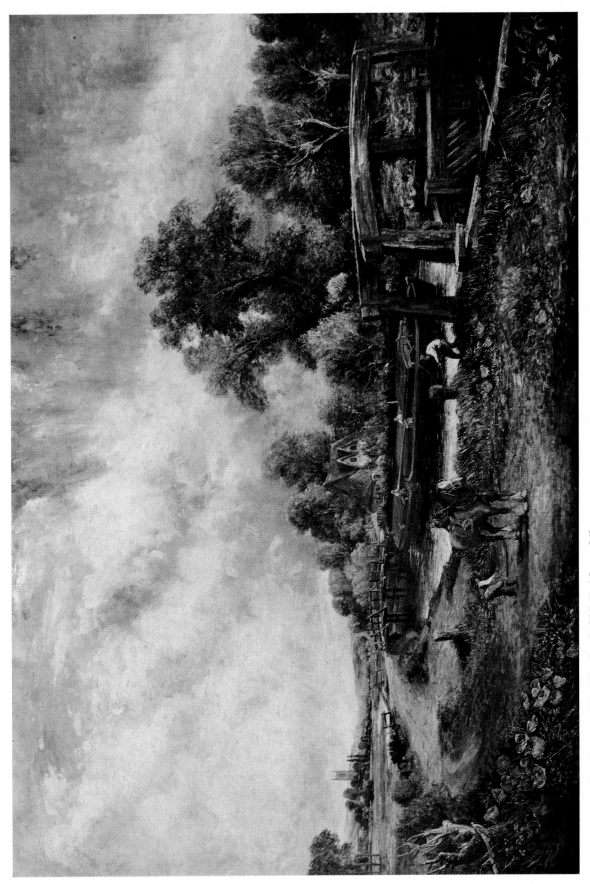

12 View on the Stour with Flatford Old Bridge. Oil

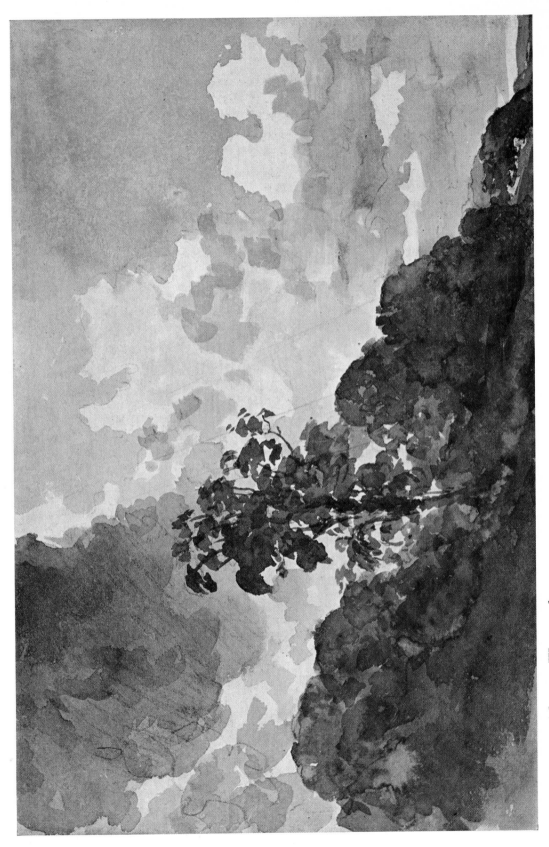

13 Sky study with tree. Water-colour

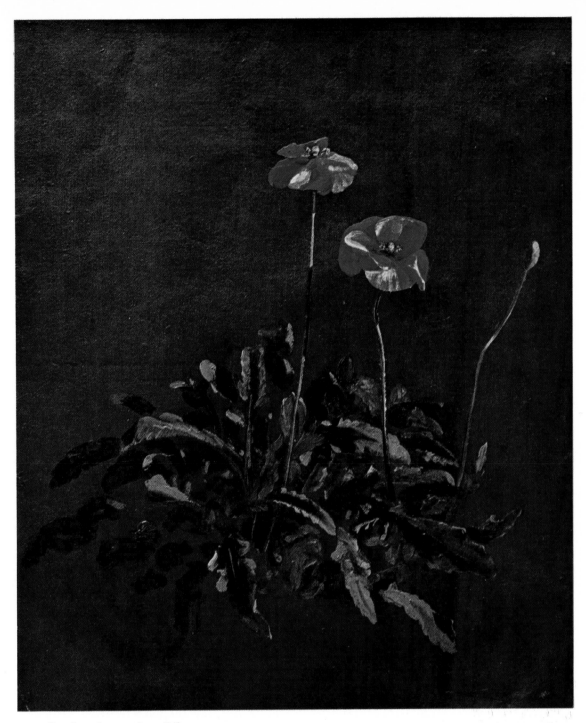

14 Study of poppies. Oil

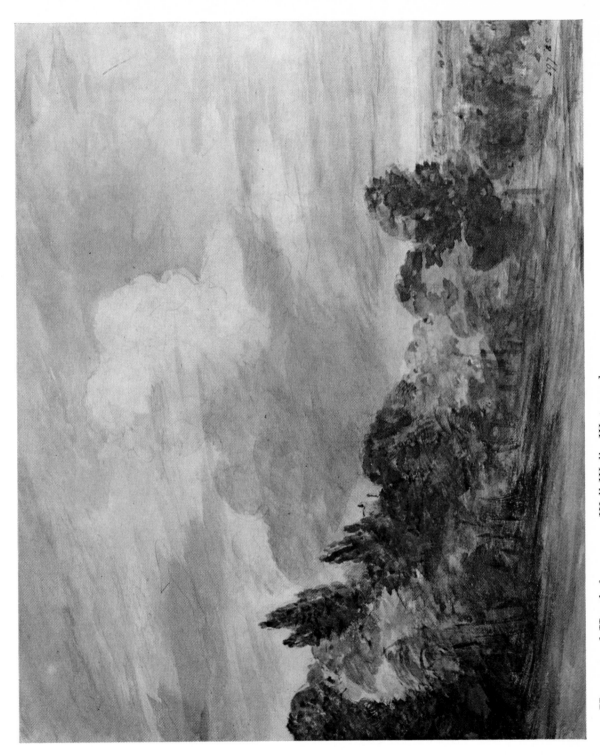

15 Hampstead Heath from near Well Walk. Water-colour

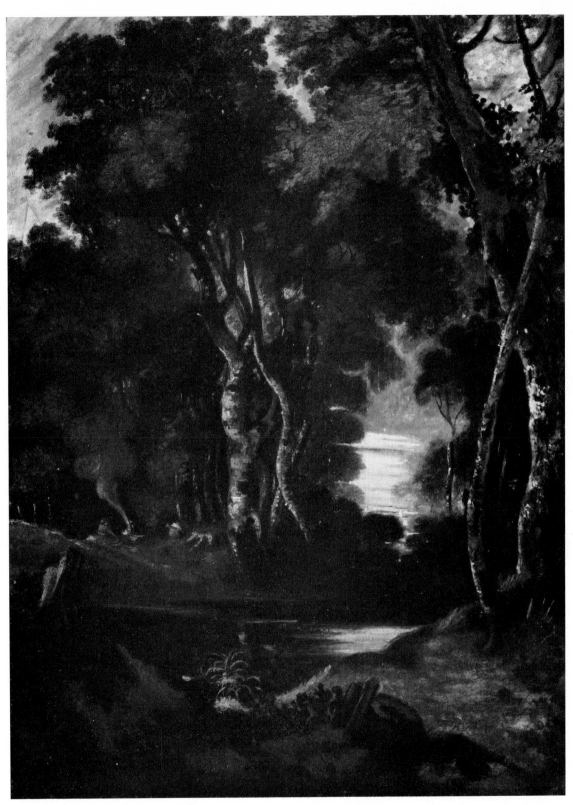

16 Moonlight landscape. Oil

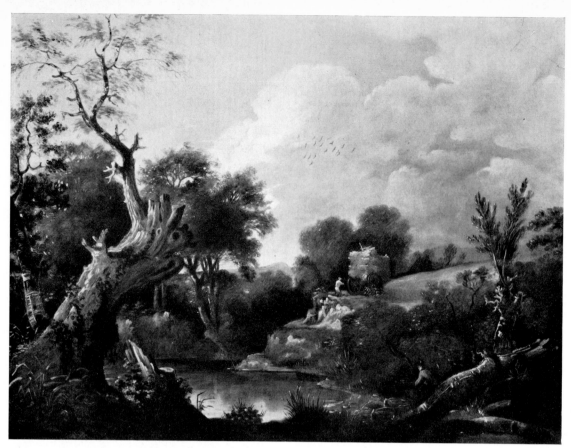

17 A harvest field. Oil. *Circa* 1796–7

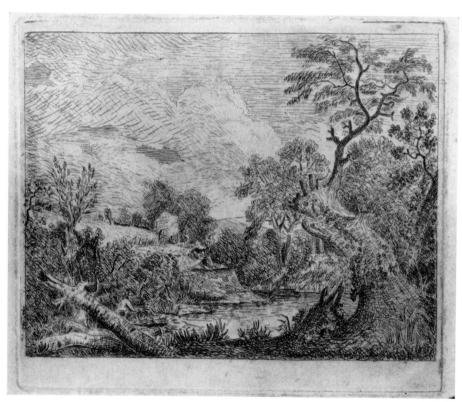

18 Etching by John Constable from his painting 'A Harvest Field'

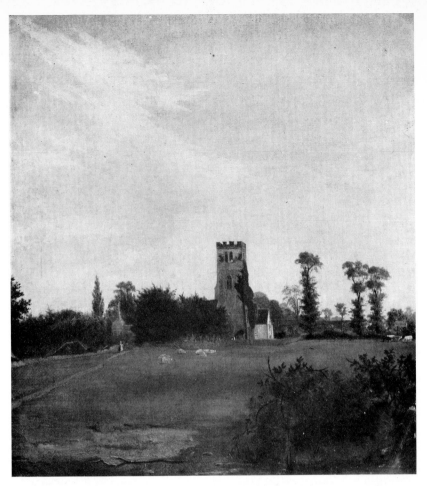

19 Tottenham Church. Oil

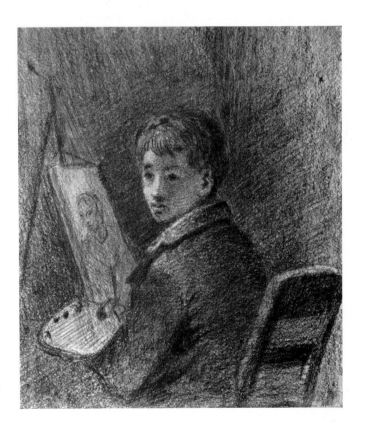

20 Boy at an easel—the artist's
son John Charles Constable

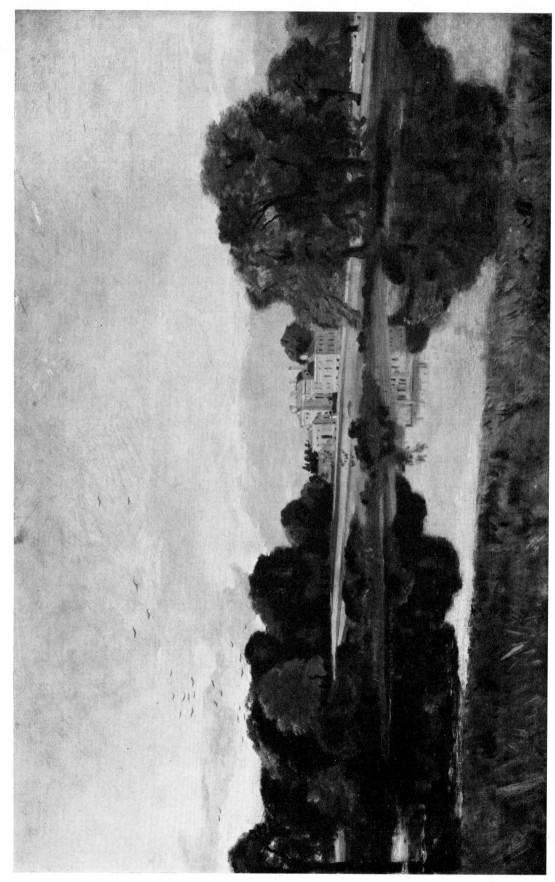

21 Malvern Hall. Oil

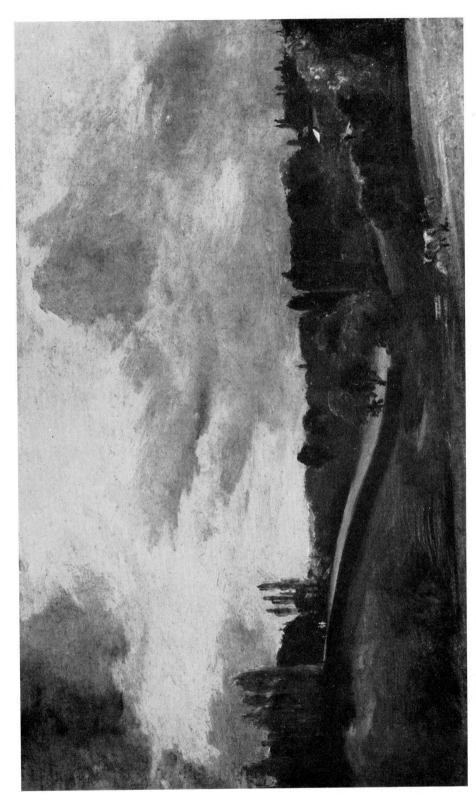

22 View at Highgate. Oil

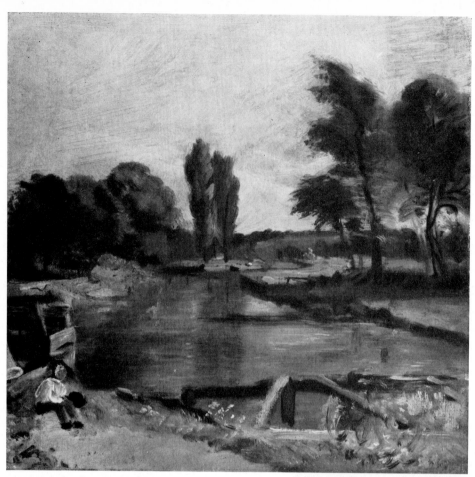

23 Lock at Flatford. Oil

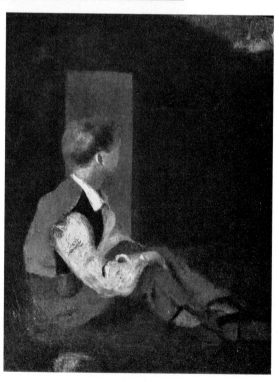

24 Boy by a milestone. Oil

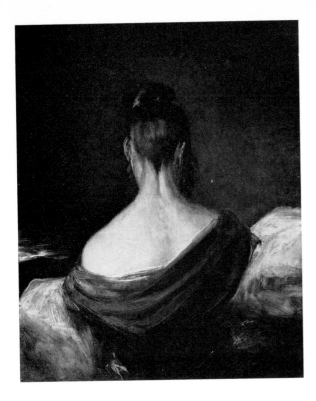

25 Head of a girl—perhaps the artist's
sister Mary Constable. Oil

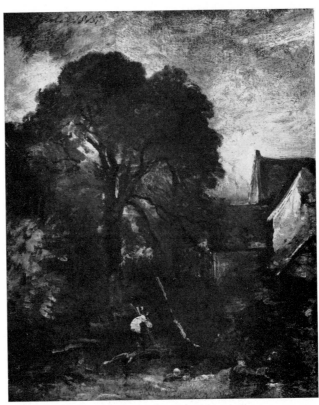

26 Sketch relating to 'The Valley Farm'. Oil

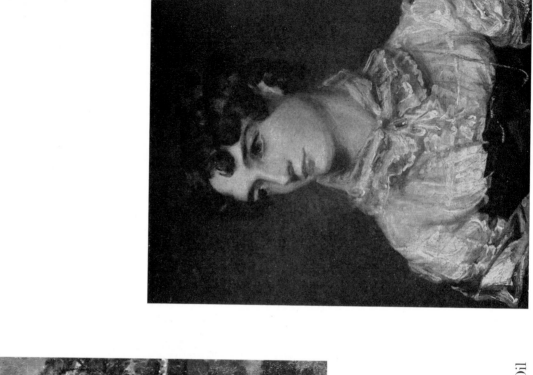

27 Flatford Mill. Oil

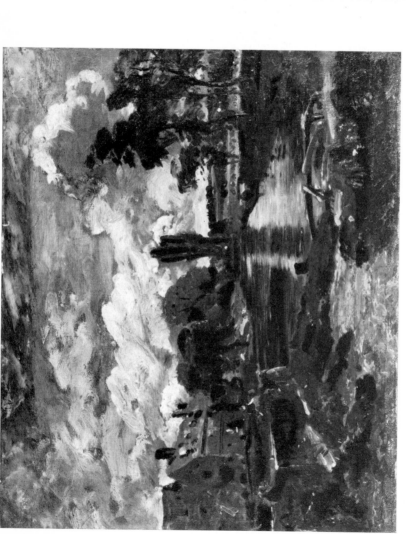

28 Portrait of Mrs Maria Constable. Oil

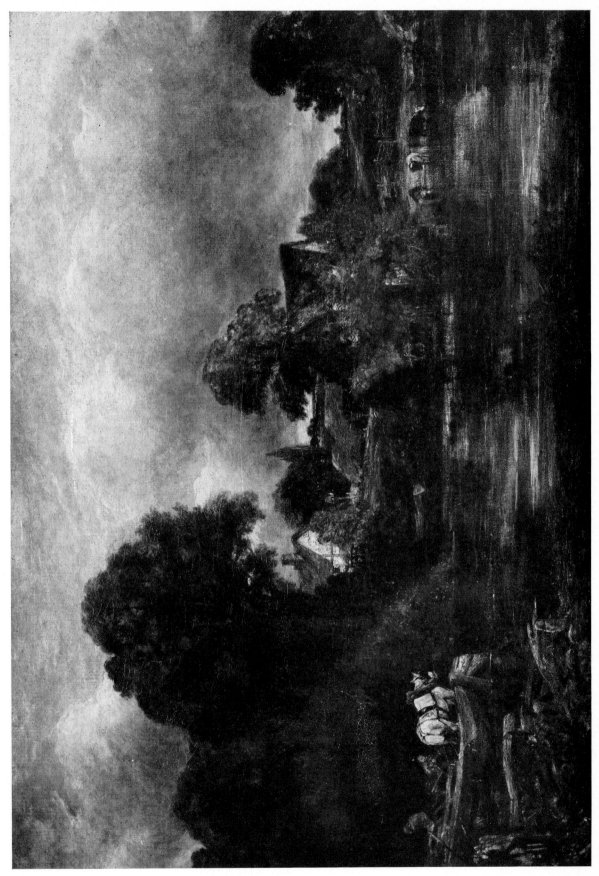

29 Sketch for 'The White Horse'. Oil

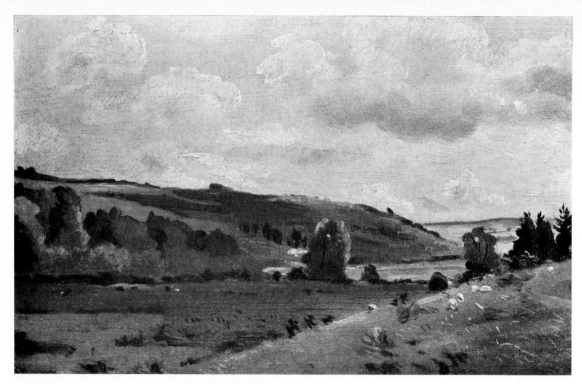

30 Summer landscape near Dedham. Oil

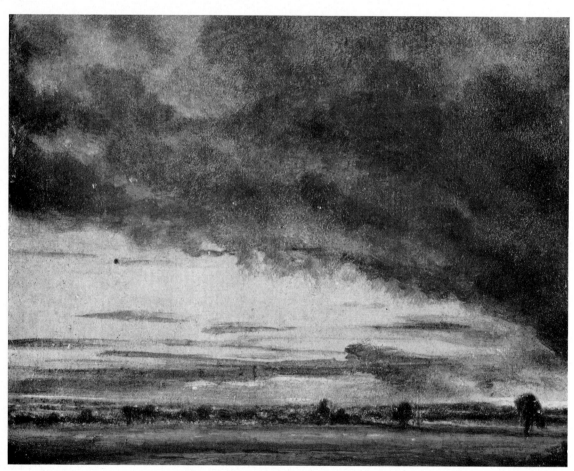

31 Evening landscape after rain. Oil

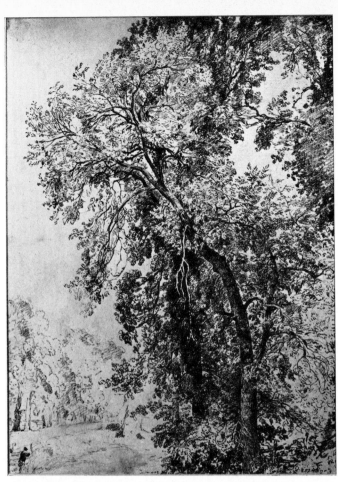

32 Study of ash tree. Pencil

33 Stoke-by-Nayland. Oil

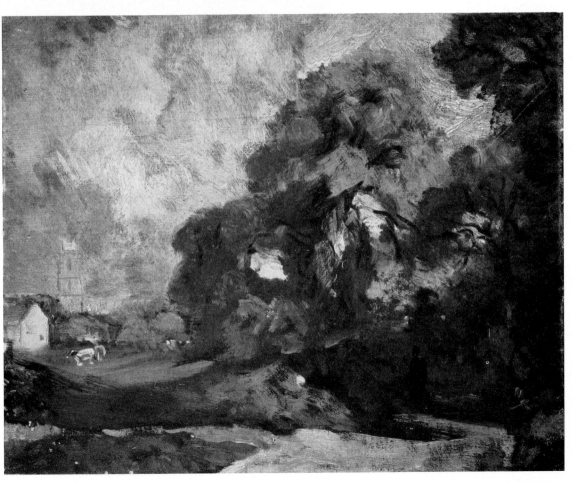

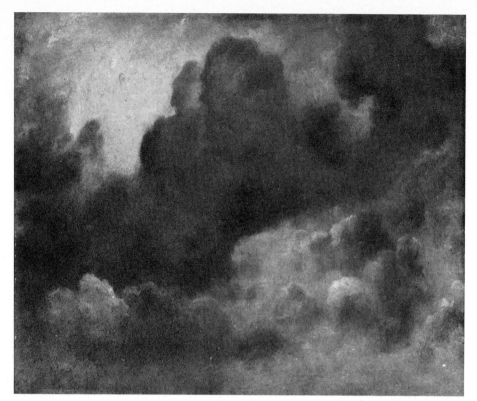

34 Study of clouds. Oil

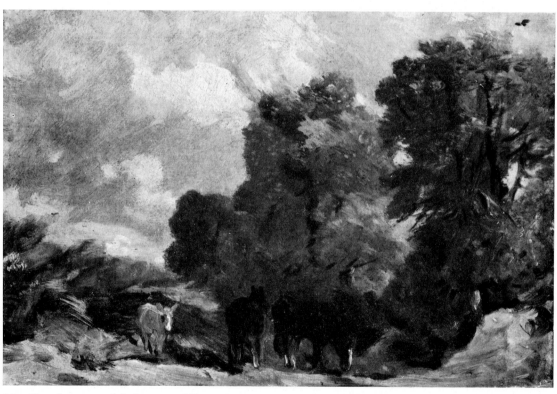

35 Landscape with horses. Oil

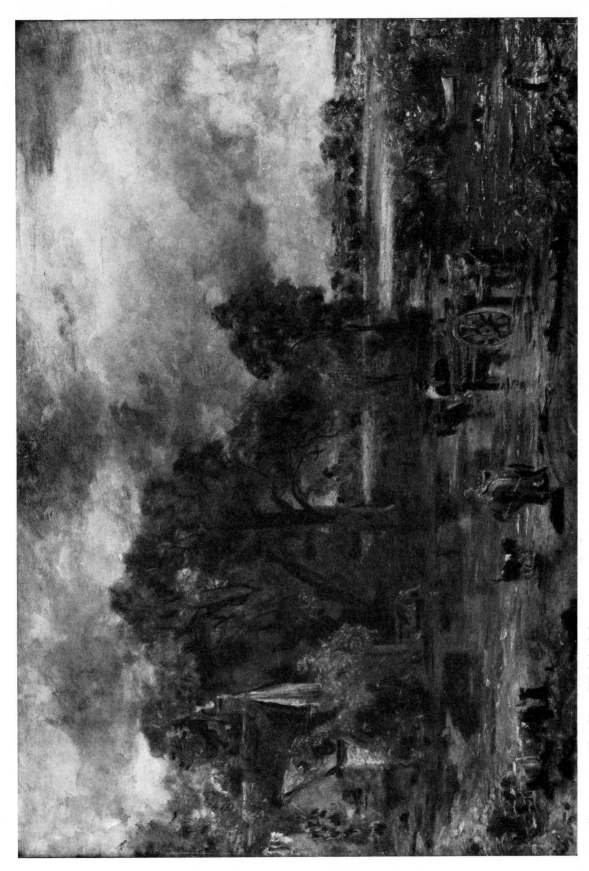

36 Study for 'The Hay Wain'. Oil

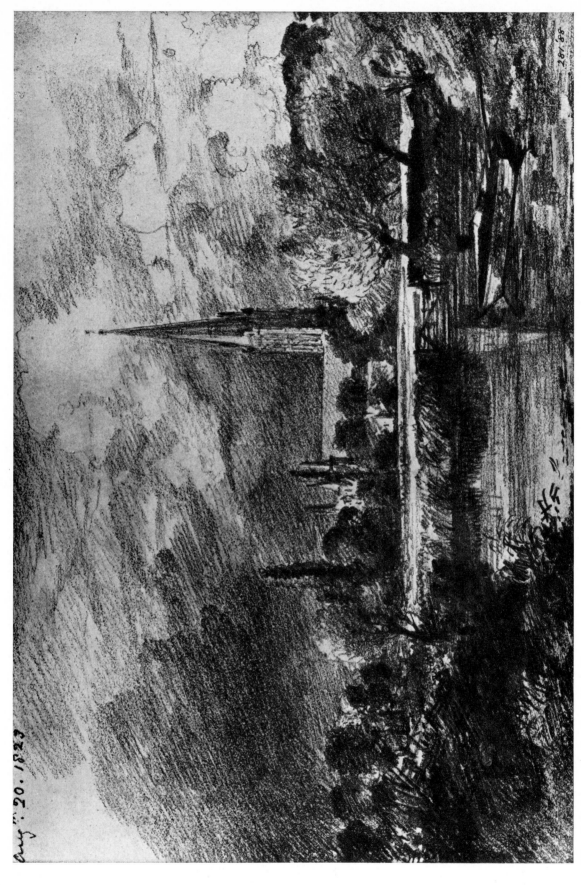

37 Salisbury Cathedral. Pencil

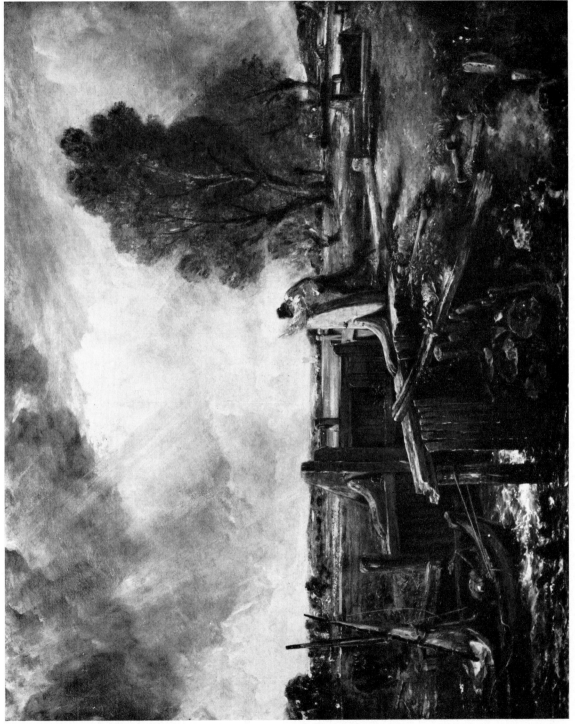

38 Sketch for 'The Lock'. Oil

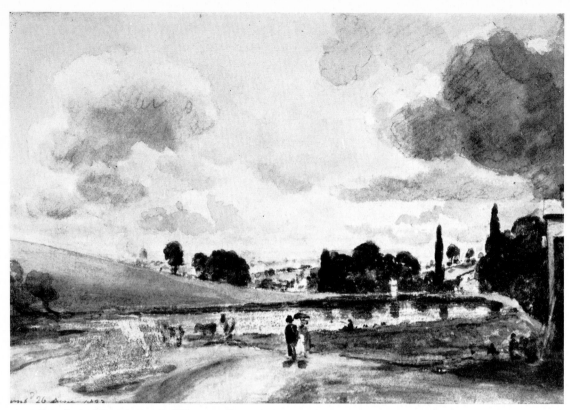

39 Pond at Hampstead. Water-colour

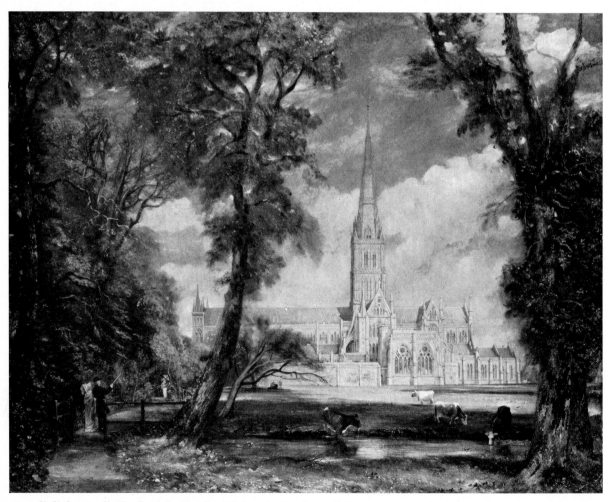

40 Salisbury Cathedral from the Bishop's Garden. Oil

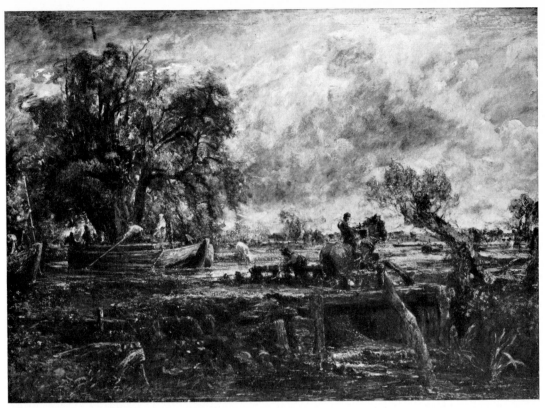

41 Study for 'The Leaping Horse'. Oil

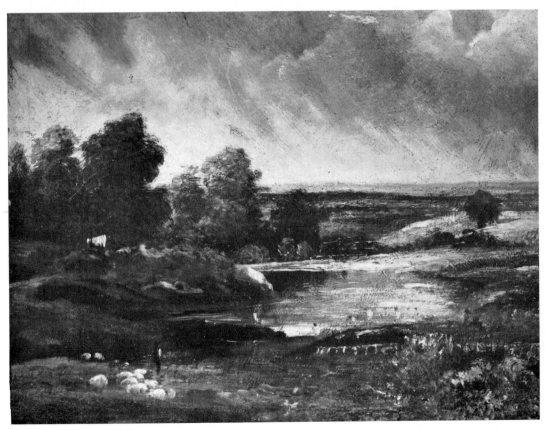

42 Hampstead Heath. Oil

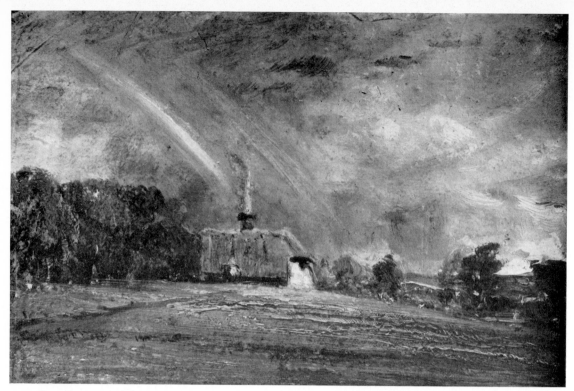

43 Landscape with cottage and rainbow. Oil

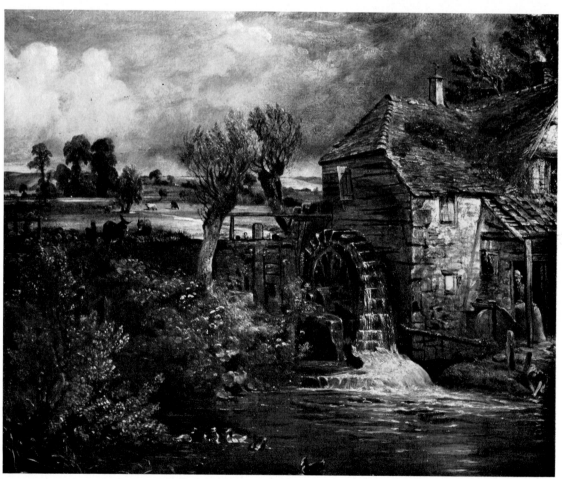

44 Parham Mill, Gillingham. Oil

45 Helmingham Dell. Oil

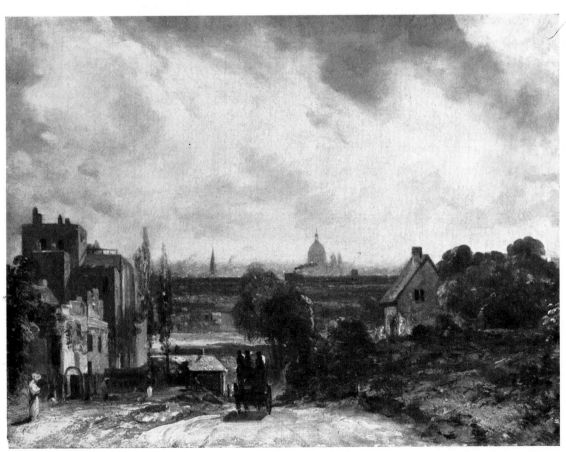

46 View of London with Sir Richard Steele's house. Oil

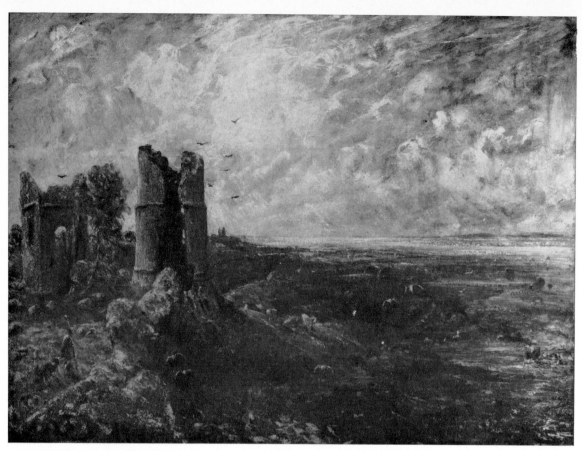

47 Hadleigh Castle. Oil

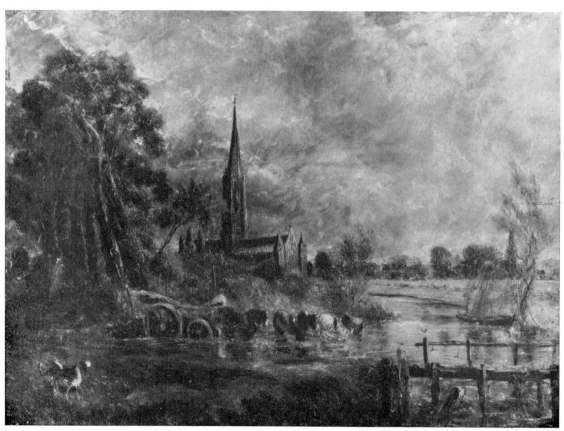

48 Crossing the Ford. Oil

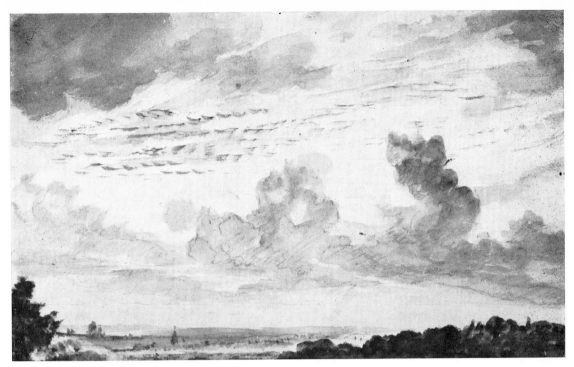

49 London from Hampstead Heath. Water-colour

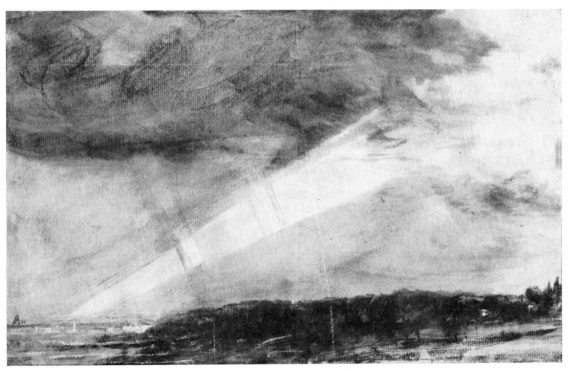

50 Landscape with double rainbow. Water-colour

Constable and the Sea

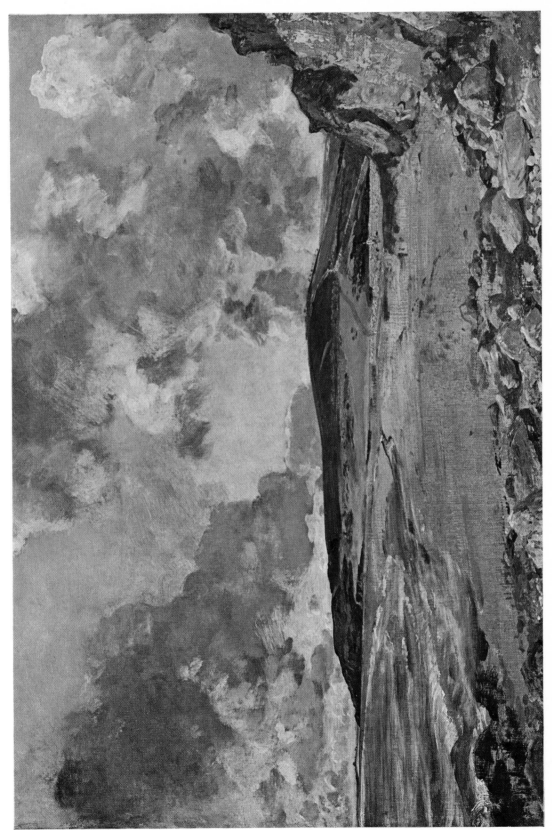

51 Weymouth Bay. Oil

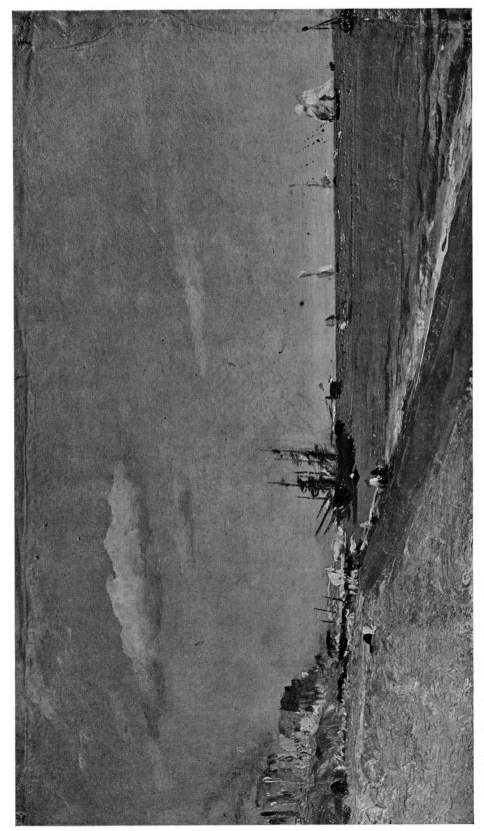

52 Brighton Beach with colliers. Oil

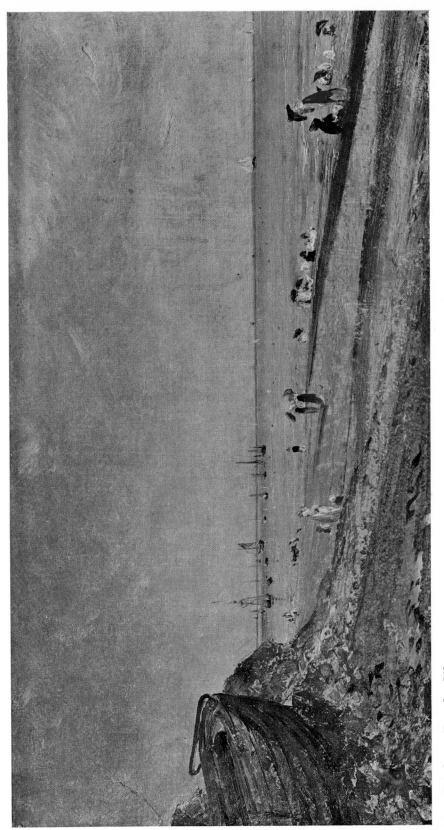

53 Brighton Beach. Oil

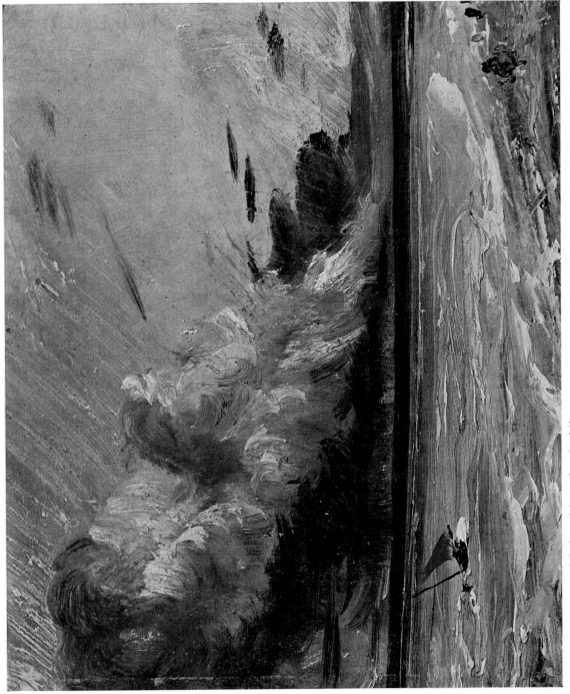

54 Coast scene with breaking cloud. Oil

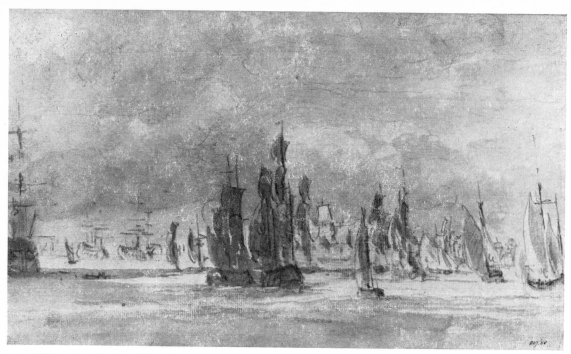

55 Shipping in the Thames. Pencil and grey wash

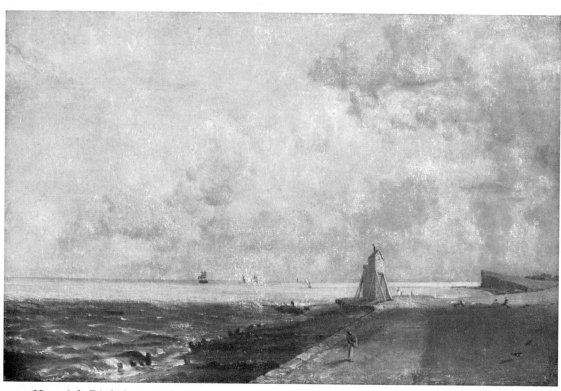

56 Harwich Lighthouse. Oil

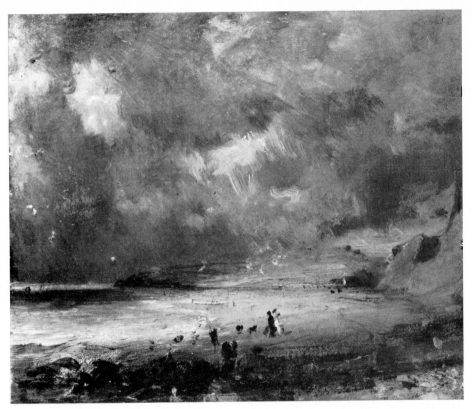

57 Weymouth Bay. Oil

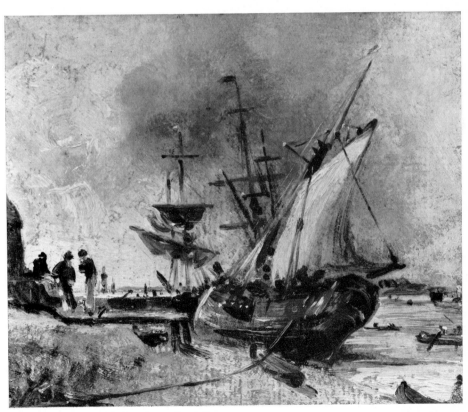

58 Shipping on the Orwell. Oil

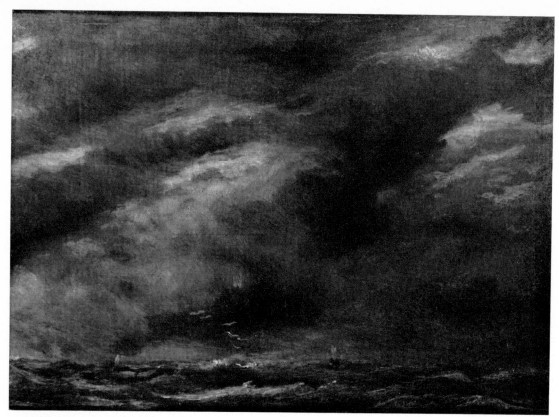

59 Sky study over a rough sea. Oil

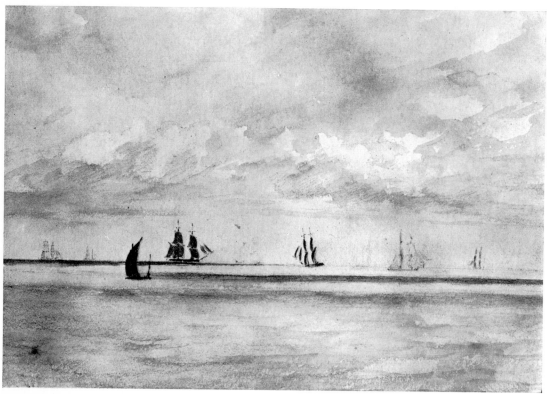

60 Sea and shipping. Water-colour

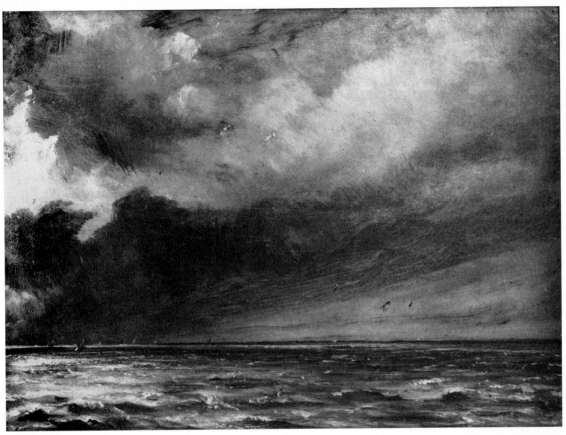

61 Study of sea and sky—probably at Brighton. Oil

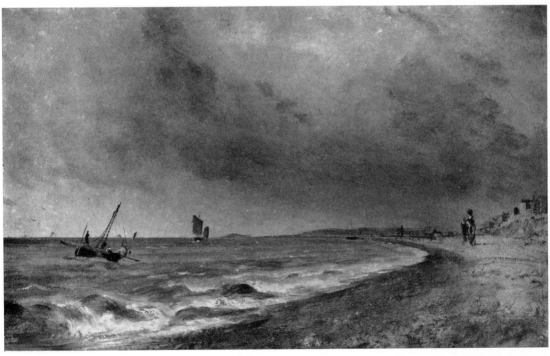

62 Hove Beach with fishing boats. Oil

63 Brighton Beach. Oil

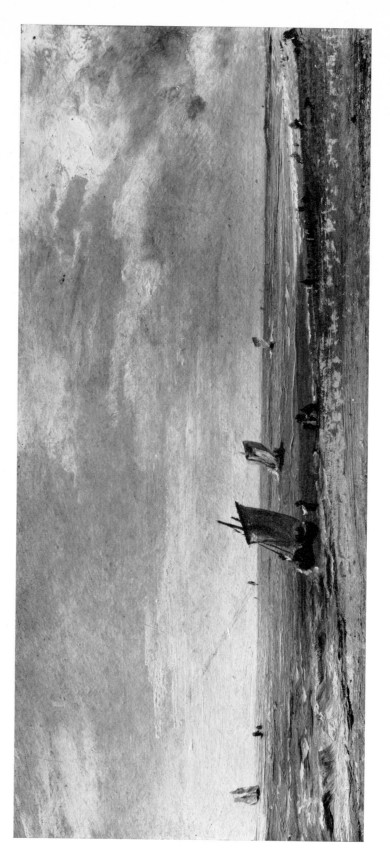

64 Brighton Beach. Oil

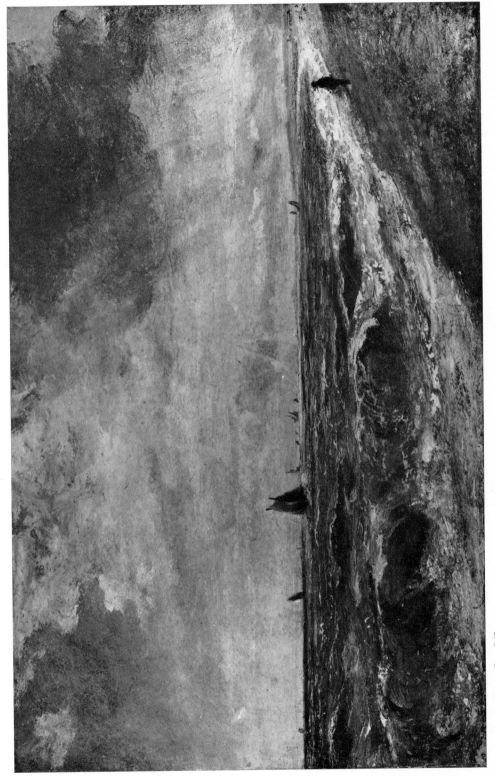

65 Hove Beach. Oil

66 Coast scene—stormy weather. Oil

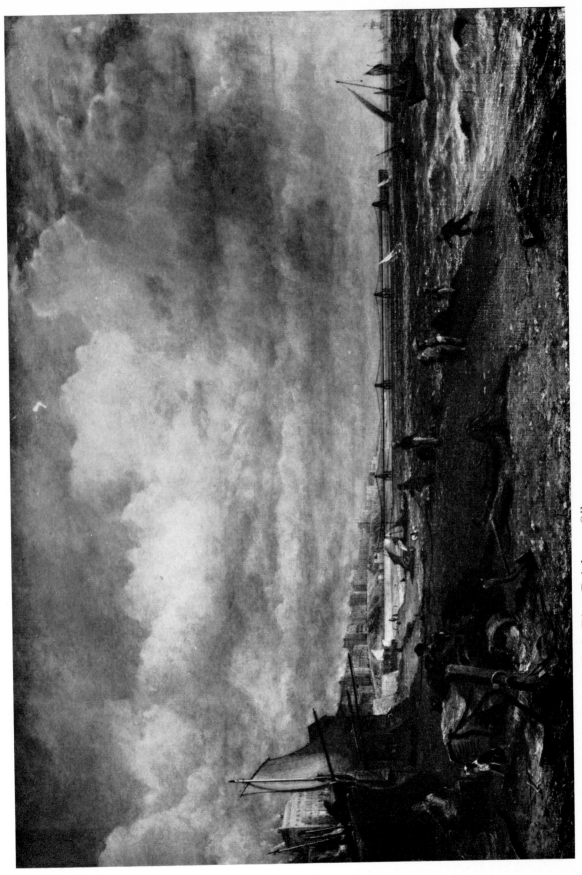

67 The Marine Parade and Chain Pier, Brighton. Oil

68 Coast at Brighton—stormy day. Oil

69 Coast scene, evening. Perhaps at Brighton. Oil

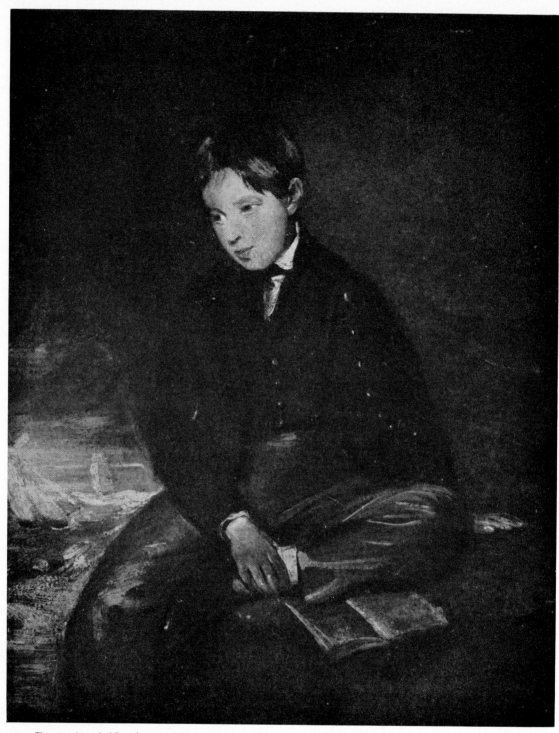

70 Portrait of Charles Golding Constable, son of the artist. Oil

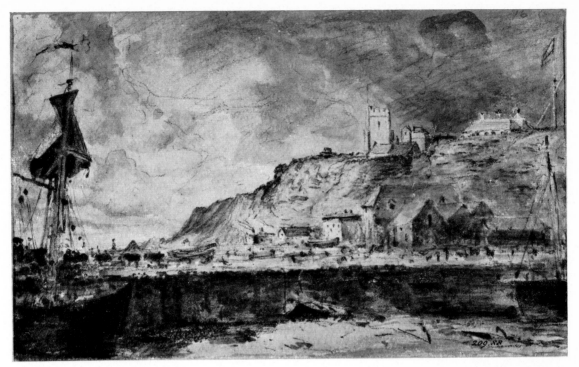

71 Folkestone Harbour. Water-colour

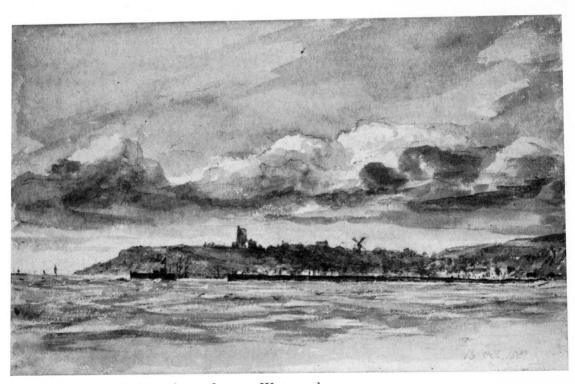

72 Folkestone Harbour from the sea. Water-colour

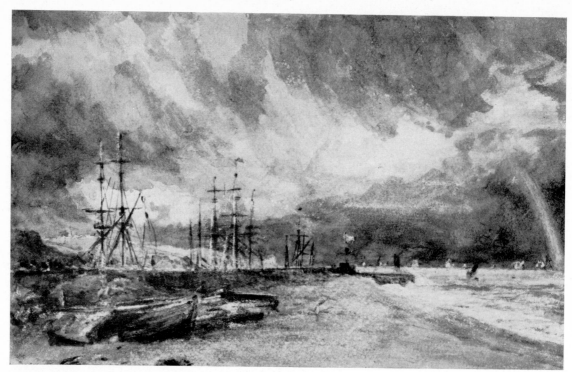

73 Seaport with passing shower. Water-colour

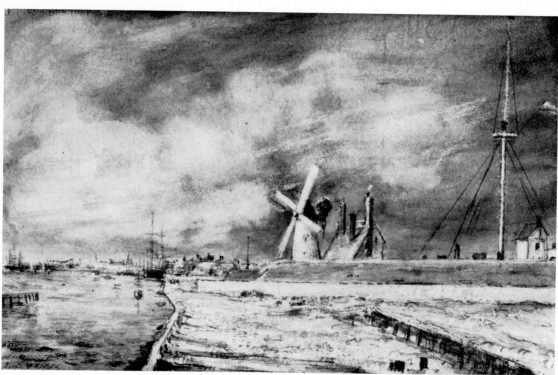

74 Littlehampton, Sussex. Water-colour

Plate 1 Oil on prepared millboard. 9 × 5½ ins. About 1816. In the opinion of R. B. Beckett, probably the original small study for the full scale painting of 'Stratford Mill', exhibited at the Royal Academy in 1820.

Plate 3 About 1818. Oil on paper laid on millboard. 19 × 11 ins.

Plate 6 Oil on paper. 9½ × 11¾ ins. 1821. Inscribed in ink on the back by the artist: 'Sepr. 12. 1821. Noon. Wind fresh at West.... [3 or 4 words rubbed out here] Sun very Hot. looking southward exceedingly bright vivid & Glowing, very heavy showers in the Afternoon but a fine evening. High wind in the night.'
 Above this is another note written in ink by the artist, but deleted: 'Sepr. 10 1821 Eleven o'clock Sultry with warm gentle rain falling large heavy clouds. ... [a word here is illegible] a heavy downpour and thunder'.

Plate 7 Pencil and water-colour. On thin paper. 7¼ × 8¾ ins. 1832. Inscribed by the artist in pencil on the back: '12 till 2—looking—East towards the (?) Sepr. . . . [date erased]—1832'.
 Also inscribed at top right on the back in ink with the serial number 17.

Plate 8 One of Constable's most brilliant and impressionistic sketches. The dating is uncertain. Dates of 1819 and 1824 have been plausibly suggested, but the extreme freedom in the use of colour makes the latter date the more likely.

Plate 9 Constable's eldest son was born in 1817. This Portrait was probably painted in 1824 or 1825.

Plate 11 A favourite subject of Constable's. There are many versions. This may be a preliminary sketch for the picture mentioned by Constable in a letter to Fisher, dated Sept. 9th 1826, and described by the artist as 'a cottage scene—with the Church Langham—'. Tradition has it that Constable painted one of his views of the Stour Valley from the top of the church tower.

Plate 12 Probably painted in the autumn or winter of 1827 after Constable had paid a visit to Flatford to look after his brother Abram. Some of the sky tones in this painting closely resemble those used by Constable in his upright landscape of 'Dedham Vale' exhibited at the Royal Academy in 1828 and now in the National Gallery of Scotland.

Plate 15 Water-colour. 4⅜ × 7⅛ ins. 1834. Inscribed on the back in pencil by the artist: 'Spring Clouds—Hail Squalls—April 12 1834—Noon Well Walk—'.

Plate 16 Painted about 1794–5, this picture shows clearly Constable's debt to Wynants and Wilson. The scene may be an elaborated reconstruction of the view from the high ground at Langham, Essex, looking towards Dedham. Constable introduces the *motif* of the gipsies again in his upright painting of Dedham Vale which was exhibited at the Royal Academy in 1828.

Plate 17 Painted about 1796–8. Here the styles of the Dutch and English painters who at this stage of Constable's development were the principal influences in his art, can be clearly distinguished in different sections of the picture. The tree in the middle distance on the left, for instance, derives from Richard Wilson; near tree and broken stump behind it, from Wynants; water and details on right from Ruisdael; sky and distant trees from Gainsborough. This painting was formerly in the possession of the artist's son, Captain Charles Constable.

Plate 19 Probably painted *Circa* 1800–01.

Plate 21 In the catalogue of the Mellon Collection a date of 1822 or even the 1830s is suggested. But the broad masses and the deep, almost sombre greens derive unmistakably from Girtin, and for this reason it seems more likely that the picture was painted a good deal earlier, possibly in 1808, a year before the painting of 'Malvern Hall'.

Plate 23 In a letter to Maria Bicknell, dated November 12, 1811, Constable writes: 'You ask me what I have been doing this summer. I fear I can give but a poor account of myself. I have tried Flatford Mill again, from the lock (whence you once made a drawing) and some smaller things'. This view from the gates of Flatford lock was probably painted in 1811.

Plate 25 If this is the head of Mary Constable it was probably painted while she was staying with Constable at 63 Charlotte Street, London, early in 1812. I am indebted to Mr C. S. Rhyne for pointing out that drawings relating to this painting are in the collection of the Fondazione Horne, Florence. One group of these drawings, which shows a woman's head in profile and another turned away from the spectator, is inscribed 'With John Constable's regard'. The inscription suggests that the subject may not be the artist's sister but another sitter—possibly Maria Bicknell.

Plate 26 This sketch may have supplied the *motif* of the figure poling a boat which appears in the oil studies for 'The Valley Farm' at the Victoria and Albert Museum, and in the full-scale version at the Tate. In composition this sketch differs from other versions in having the principal tree placed on the left, and the figure here appears to be using a pole to manoeuvre a floating branch instead of a boat. Though in the full-scale version at the Tate, Constable has given the house in the background more imposing proportions and altered the angle of the roof lines slightly, he has apparently based the general design of the building on that in the sketch. The date 'June 1814' inscribed at the top of the canvas on the left almost certainly indicates that the subject was painted from nature.

Plate 29 Full size study for the painting now in the Frick Collection, New York.

Plate 35 Possibly a view in the New Forest, painted in 1820 when Constable was staying with Archdeacon Fisher at Salisbury. A drawing in the Victoria and Albert Museum is inscribed by Constable: 'New Forest Aug. 4 1820'.

Plate 36 Study for the picture in the National Gallery, painted 1820–21.

Plate 37 There are at least seven recorded versions of this subject. This one probably dates from 1825.

Plate 38 Study for the picture in the Diploma Gallery, Royal Academy, London.

Plate 41 A preliminary version of the picture exhibited at the Royal Academy in 1825 and now in the possession of the Royal Academy, London.

Plate 44 Based on sketches made by Constable when on a visit to Gillingham, Dorset in 1823. Exhibited at the Royal Academy in 1826. A study of this subject by Constable is in the Fitzwilliam Museum, Cambridge.

Plate 48 One of the last of Constable's great Salisbury paintings, based on sketches made on his last visit to Archdeacon Fisher in 1829. This painting is a preliminary study for the picture exhibited at the Royal Academy in 1831. In the final version Constable painted a rainbow over the cathedral spire.

Plate 52 An inscription by Constable in pencil on the back of this painting reads: '3d tide receeding left the beach wet—Head of the Chain Pier Beach, Brighton July 19 Evg., 1824, My dear Maria's Birthday Your Goddaughter—Very lovely Evening— looking Eastward—cliffs and light off a dark grey [?] effect—background—very white and golden light'. Also inscribed: 'Colliers on the beach'.
 Later Constable sent a number of his Brighton oil sketches to Fisher. That this must have been one of them can be assumed by the reference in the inscription to 'Your Goddaughter'.

Plate 53 Inscribed on the back in ink by the artist: 'Beach Brighton 22d July, 1824 Very fine Evening'.

Plate 55 One of the drawings made by Constable on his voyage from London to Deal in April 1803.

Plate 56 Generally ascribed, on account of its subject, to the year 1816, but as R. B. Beckett points out the style of the painting has little affinity with works known to have been painted at Osmington in that year. Possibly this is 'the little Osmington Coast' which Constable tells Maria he was working on when Fisher called at Charlotte Street on June 18th 1824.

Plate 62 Probably painted in 1824.

Plate 63 Inscribed by Constable in pencil on the back: 'June 12th 1824'.